TIBETAN
RELIGIOUS ART

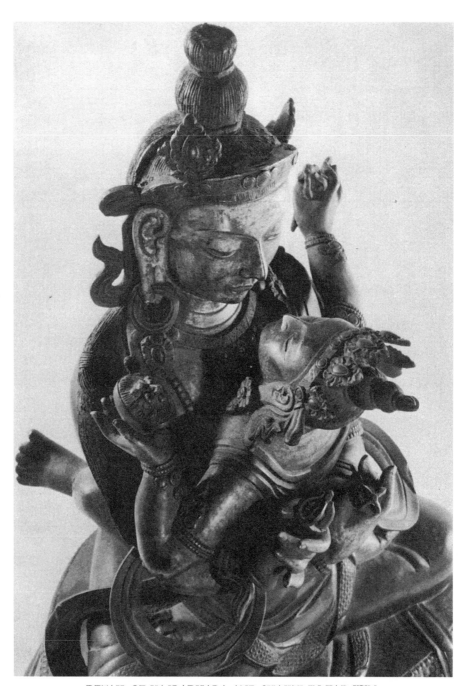

DETAIL OF VAJRADHARA AND SHAKTI IN YAB-YUM

ANTOINETTE K. GORDON

TIBETAN RELIGIOUS ART

DOVER PUBLICATIONS, INC.
Mineola, New York

Bibliographical Note

This Dover edition, first published in 2002, is an unabridged republication of the work originally published in 1952 by Columbia University Press, New York. The only significant alteration consists in reproducing the two color illustrations in the book, found on pages 27 and 31, in black and white in their current positions, and in color on the inside front cover and the front cover, respectively.

Library of Congress Cataloging-in-Publication Data

Gordon, Antoinette K.
 Tibetan religious art / Antoinette K. Gordon.—Dover ed.
 p. cm.
 Originally published: New York : Columbia University Press, 1952.
 Includes bibliographical references and index.
 ISBN 0-486-42507-X (pbk.)
 1. Art, Tibetan. 2. Art, Buddhist—China—Tibet. I. Title.

N8193.C6 G67 2002
704.9'48943—dc21

 2002031225

Manufactured in the United States of America
Dover Publications, Inc., 31 East 2nd Street, Mineola, N.Y. 11501

To My Husband

MILTON GORDON

WHOSE DEVOTION AND ENCOURAGEMENT
ARE MY CONSTANT INSPIRATION

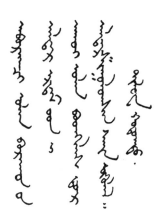

Sage discourse,

Spreading the renown of all the

Savior Buddhas unto

Souls of all living creatures.

DILOWA HUTUKHTU

This dedication was written by His Reverence, Dilowa Hutukhtu, a reincarnate Buddha of Mongolia. The translation, made by Owen Lattimore of the Johns Hopkins University, follows the alliterative form of the Mongolian original.

PREFACE

THE ARTS of China, Japan, and India have been familiar to the general public for many years, while the art of Tibet, "The Land of Snows," or "The Forbidden Land," is almost as remote as the country itself. However, in recent years the interest in Tibet has steadily increased. There has long been a need for a simple book that will answer questions concerning Tibetan art, its origins, functions, and the symbolism which is such an important factor. It is hoped that this book will answer that need to some extent. The favorable reception of my previous book, *The Iconography of Tibetan Lamaism* (1939), has encouraged me to make this material accessible to a wider public.

The time is not yet ripe for a thorough, comprehensive study of Tibetan art. That time will come when those sections of the Tibetan Canon dealing with the treatises on painting and sculpture shall have been fully translated.

The Tibetan language is a difficult barrier, because as yet there has been no standardized transliteration. Here, I have used approximate phonetic spellings wherever possible and omitted all diacritical marks.

Tibetan art is essentially a religious art. Religious art in the Orient differs from that of the Occident in that the lama regards his work, not as a work of art, but as a vehicle for expressing in a world of form the metaphysical concepts of "The Religion."

There has recently been offered an interesting distinction between "religious" and "sacred" art. Peter Fingesten, in his "Toward a New Definition of Religious Art," *College Art Journal*, Vol. X, No. 2, 1951, puts it this way: "Sacred art is canonical, liturgical, didactic, guided by ecclesiastic rules and intended exclusively for worship, and is anonymous; while religious art is inspired, free, individual and not necessarily intend-

ed for worship." According to this standard, Tibetan art is primarily a "sacred" art. But I shall use the term "religious art" as being a broader term. Most of the art was "sacred" and used for worship — the *thang-kas*, images, votive tablets, and books. There were many things such as metal work, jewelry, charm boxes, musical instruments, and other objects which were later used for lay purposes, but were decorated with religious symbols. As the art of Tibet is based upon their religion, the first chapter is devoted to "The Religion".

The objects used in the ritual were made according to canonical rules in the monasteries by the monks themselves or by artists traveling from one monastery to the other. For this reason there is very little free expression in the handling of subject matter. However, a good painting by a competent artist may always be easily recognized.

Materials and techniques employed by the monks are described in the text. The dating is controversial, as the objects were never signed by the artists, except in rare instances, when a painting or an image was made for a special votive offering, and an inscription and a date were inscribed. Sometimes it is possible to approximate dates by the colors and techniques used. Tibetan art was influenced by India, Nepal, Persia, China, and Mongolia. In Southern Tibet, the Indo-Nepalese tradition prevailed; in the north, the influences came from China and Mongolia.

I have used the Sanskrit names and terminology in most instances, as Sanskrit is the language of the Buddhist scriptures, which were later translated into Tibetan. Unfamiliar languages and physical inaccessibility may be barriers, but art is international and not circumscribed by country or political circumstances. Through the art of a country even as remote as Tibet we can come to an understanding of its people. By studying Tibetan art we establish a cultural bridge which will bring the Tibetans and their religion near to us in the West.

The complex mythology is difficult for the student until he understands the symbolism and becomes familiar with the images. His comprehension depends upon his desire to understand and his sympathetic approach. When the significance of the symbols is understood, the

images become familiar and lose their strangeness. It is then that appreciation begins.

My thanks are due to the many friends who requested this book and encouraged me in my work. I am especially grateful to Lola Mautner, whose questions and suggestions were most helpful, and to Peter Fingesten for reading the manuscript and giving valuable aid.

New York A. K. G.

CONTENTS

ILLUSTRATIONS

TIBETAN
RELIGIOUS ART

གང་ ལ་ ཡོན་ དན་ མཆོག་ མངའ་ བ

gang la yon tan mchog mngah ba

who to supreme intelligence is

སངས་ རྒྱས་ དེ་ ལ་ ཕྱག་ འཚལ་ ལོ

sangs rgyas de la phyag htshal lo

Buddha to salutation

SALUTATION TO THE BUDDHA, WHO HAS
SUPREME INTELLIGENCE!

BUDDHISM AND
LAMAISM

THE RELIGION of Tibet is known to us as "Lamaism." Lamaism is one of the later developments of Buddhism, and Prince Gautama Siddhartha is generally recognized as its founder. He was a historical person, a prince of India, born about 620 B.C. in Kapilavastu, the capital of a small principality in Nepal, northern India. It was prophesied shortly after his birth that he would eventually renounce his family and throne and become a "savior of mankind." This he did, leaving his home and family at the age of twenty-nine to become a religious ascetic, hoping by doing so to solve the meaning of life.

After six years of discipline and association with the famous ascetics and anchorites of his day, he decided that their extreme austerities were not the solution, but that the "Middle Way" was the right path to follow. This meant neither self-mortification nor self-indulgence. After a long period of profound contemplation Gautama came to a realization of the "Truth," the causes underlying the sufferings of humanity. Thus, he became the Buddha (which means Awakened, or Enlightened One) and formulated his doctrine of the Four Noble Truths: life is suffering; the cause of suffering is desire; desire must be overcome; then there will be no more suffering or rebirth. Desire can be overcome by following a code of conduct which he outlined in his First Sermon in the Deer Park near Benares. This code he called "The Noble Eightfold Path," namely: (1) right views — freedom from delusion; (2) right aims — high and worthy thoughts; (3) right speech — truthfulness; (4) right actions; (5) right effort — self control; (6) right mindedness — an active mind; (7) right means of livelihood; (8) right rapture — meditation on the realities of life.

The five commandments which the Buddha laid down for the layman were that he abstain: from taking life; from drinking intoxicants; from lying; from stealing; and from unchastity. For the monks who took the vows of celibacy and lived in communities called "viharas" the rules and discipline were much more severe. The worship of gods and deities did not enter into primitive Buddhism, which was primarily a code of ethics and conduct.

Buddha preached for forty-five years, and after his death his disciples traveled from place to place spreading his doctrines and collecting his teachings, which up to the time of his death were transmitted orally. Gradually Gautama became deified. Some of the scriptures were reduced to writing about three hundred years after Buddha's death. The earliest date of the writings was in the reign of King Ashoka — 250 B.C. in Pali and some other Middle Indian Prakrit dialects. They were not complete. In North India, in the second half of the first century A.D. there were further collections by King Kanishka. The sacred books are known in Sanskrit as the Tripitaka (Three Baskets).

Later these books were translated into Tibetan. They are known as the Kanjur, that is, "The Translated Commandments," and the Tanjur, "The Translated Explanations." The Kanjur consists of 108 volumes. It is the bible of the Tibetan Buddhists, based on the Tripitaka, with Tantric additions. The Tanjur comprises 225 volumes, of treatises on grammar, poetry, logic, rhetoric, law, medicine, astrology, divination, chemistry, painting, and biographies of saints.

Buddhism began to spread beyond India. First it reached China, then Korea, then Japan. In the seventh century it reached Tibet. By this time, however, Buddhism had split into two main schools, known as Hinayāna and Mahayana Buddhism. One of the fundamental differences between these two was that the Hinayana school adhered more closely to primitive Buddhism (the original teachings of Gautama), whereas the Mahayana school brought in the worship of deities and elaborate ritual. Primitive Buddhism was essentially an intellectual religion in which one had to work out his own salvation through meditation and the suppression of desires in the sense of nonattachment to

worldly or material things, whereas Mahayana Buddhism became an emotional religion wherein *bhakti*, devotion or faith, was the principal requisite and one had only to call upon the "name of Buddha" in order to be saved. Mahayana Buddhism also developed a group of Bodhisatt-vas, or potential Buddhas, who became the intercessors upon whom the people called for help in order to attain salvation.

The native religion of Tibet, called Pön, was a form of demonolatry and nature worship. It was a primitive Shamanist faith, in which the wizard priest, or shaman, was the principal figure. In the shaman's hands lay the fate of all the people. He was priest and doctor, and was respected and feared by everyone. He employed all manner of magic charms and incantations, and the evil spirits were propitiated and sub-jected to his power.

Until the eighth century Buddhism made little progress in Tibet. Then Padmasambhava, a famous teacher from the great Buddhist University at Nalanda, India, was invited to come to Tibet. He ac-cepted some of the Pön deities into the Buddhist Pantheon, thereby conciliating the native priests. This fusion of the native religion with Mahayana Buddhism became the religion of Tibet. By occidentals it is called Lamaism, the name deriving from *bla-ma*, Tibetan for monk, or superior one; but the Tibetans simply call their religion "The Religion" or "Buddha's Religion."

In the course of time Lamaism was divided into several sects, the three main sects at the present day being the orthodox Ning-ma-pa (known familiarly as the Red Cap Sect), the Kar-gyu-pa (the White Sect), and the Ge-lug-pa (the Yellow Cap Sect). The Red Cap Sect was founded by Padmasambhava in the eighth century. It contains more of the Pönist ideas and superstitions than do the later reformed sects. The White Sect, the Kar-gyu-pa, was founded in 975 by Tilopa. His teachings were transmitted to Naropa, who in turn was the teacher of Marpa. Marpa's chief disciple was Mila-repa, most loved of the Tibetan saints. The Yellow Cap Sect, known as the Ge-lug-pa, or Virtuous Ones, was founded by Tsong-kha-pa in the fifteenth century. Tsong-kha-pa made many reforms in discipline and enforced the monastic

rules, which had become very lax. Today this Yellow Cap Sect is the dominant sect in Tibet.

The Dalai Lama is the "Priest-King" of Tibet, while the Tashi Lama is the spiritual leader. Abbots of important monasteries are often called "Living Buddhas" by occidentals, because the Tibetans consider them continuous incarnations of certain Buddhas and Bodhisattvas (potential Buddhas). For example, every Dalai Lama is regarded as the incarnation of the Bodhisattva Avalokiteshvara (Tibetan, sPyan-ras-gzigs; pronounced Chen-re-zi), The Compassionate One, who is the patron saint of the Yellow Cap Sect.

The succession of the Dalai Lama and that of the Tashi Lama is not hereditary, but is determined by special conditions and by the oracles. When a Dalai Lama "retires to the Heavenly Fields," the lama-astrologers consult the oracle at Na-chung, where the official government astrologer also resides, for information concerning the locality in which the new incarnation may be found. Often the Dalai Lama himself, before dying, gives some indication of the locality.

All the male children who were born at the time of the Dalai Lama's death and who possess certain physical characteristics that are believed to indicate a reincarnation are examined, and circumstances at the time of their birth are investigated. The potential applicant is confronted with various personal belongings, among which are articles which belonged to the late Dalai Lama. If he selects and recognizes those which belonged to him, that is another auspicious sign. When the identity of the newly incarnated Dalai Lama is finally determined, the child is brought to Lhasa in state. He lives in the palace under the tutelage of the Regent until he becomes of age, when he assumes full control.

The Tashi Lama is also a "Living Buddha." He is the spiritual head of Tibet and is regarded as an incarnation of Amitabha, the Buddha of Infinite Light, who is the source of wisdom and the creator of this world cycle. The Tashi Lama has no temporal powers; his domain and authority are entirely in the spiritual realm. The photograph on page 8 shows the late Tashi Lama, Pan chen blo bzang tub bstan chos kyi nyi

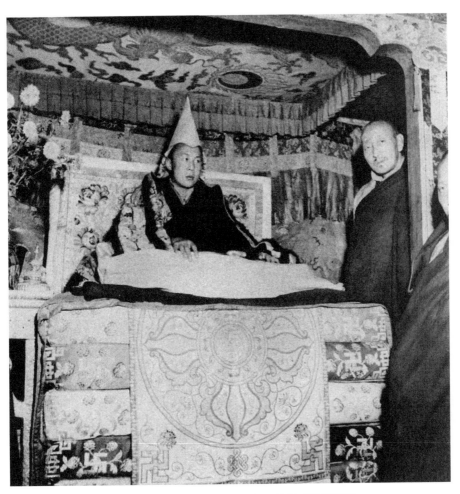

HIS HOLINESS, THE DALAI LAMA OF TIBET

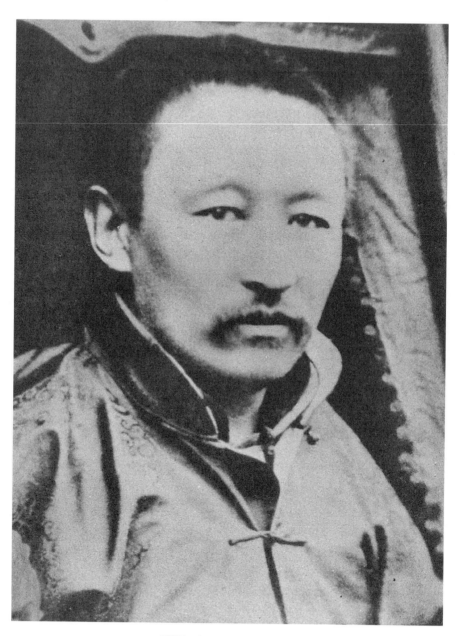

THE LATE TASHI LAMA

mahi. He was an exile in China for many years because he differed with the Dalai Lama on religious issues. He died in 1937, on his way back to Tibet. At this writing, the new Tashi Lama is thirteen years old. He resides at Kumbum Lamasery, on the northwestern Chinese-Tibetan border.

"The Religion" is the dominant factor in the lives of all the Tibetan people. There is a saying in Tibet that "without a lama there is no way to God." The lamas are consulted on every occasion, and no undertaking, however small, is entered into without their advice. They also hold many of the important civil positions. In almost every family at least one person enters a monastery. About 30 percent of the Tibetans are connected with the monasteries in some way, either as monks or in the lay service.

The importance of the lamas' influence in the daily lives of the people cannot be overestimated. They desire isolation for the purpose of living their religion, and in accordance with the tenets of their religion they do not wish to take life. In consequence they are totally unprepared for the political crises now at hand. It will take a long time to determine the ultimate result of the conflict between their religion and politics.

Tibet has captured the interest and imagination of the West. If anything can be done to help her in her present struggle for freedom of religion and her way of life, it can only be accomplished by understanding her "way of life" and her religion.

THE PANTHEON OF
DEITIES AND DIVINITIES[1]

ART in Tibet is an expression of "The Religion". The deities of the pantheon are numerous and are depicted in special ways. Their appearance and attributes and colors differ according to their functions. For this reason it is important to know the various classifications of the pantheon itself. Buddhism took many Hindu deities into its fold, and wherever the religion spread it absorbed many of the indigenous gods and demons. The orthodox, or Red Cap sect not only has many of the Pönist gods in its pantheon but also makes much use of charms and spells and other forms of magic which were not permitted by the reformed sects. The classification of the principal deities, however, is basically the same in all sects. The sects differ somewhat in the ritual and in the Buddhas they worship as supreme. In the Tibetan religious books, the Tanjur, or Commentaries, are to be found descriptions of the various deities and how they are to be depicted in painting and sculpture. Everything must be done according to these rules.

In the past most of the ritual objects were made in the monasteries by the monks and their acolytes. Occasionally a painting will have the imprint of the hand of a high lama on the back, and at times also an invocation or the Buddhist creed.[2] The images and ritual objects have a hollow space in which prayers and invocations are inserted at the consecration, after which the opening is sealed. This makes them "sacred images."

[1] According to Webster's Dictionary a deity is a god, whereas a divinity may be one having "divine" qualities. We should use both terms: "deities" for the gods, and "divinities" for the saints and teachers who are worshiped.
[2] See p. 48 for illustration.

Many images which have come out of Tibet have been opened, and the prayers have been removed. Although this detracts from their "religious significance," as objects of study from the aesthetic or iconographical standpoints, they have their value.

A general classification of the deities of the pantheon is as follows.

The Supreme or Adi (first) Buddha is the Author of the Universe.

The Buddhas, who are the spiritual sons of the Adi-Buddha, are classified according to their particular functions. *The Five Dhyani Buddhas* are the creative Buddhas. *The Manushi Buddhas* are mortal or earthly Buddhas. Some of these lived before the historical Gautama.[3] Gautama was a *manushi* (earthly) Buddha in his last incarnation. *The Medicine Buddhas* are the healing Buddhas. *The Confession Buddhas* are those invoked in the confession of sins. Lastly, Maitreya is *The Future Buddha*, who waits in the Tusita heaven. This Buddha will appear on earth when the time comes to renew the faith.

The Bodhisattvas are the potential Buddhas. There are several groups of them. The main group is the "five Dhyani Bodhisattvas," who are the spiritual sons of the five Dhyani Buddhas. Another group consists of eight Bodhisattvas. A still larger group of independent Bodhisattvas includes both male and female divinities, including the Taras (the Savioresses); the Pancharaksha (Spell Goddesses, who protect from diseases); Sarasvati (Goddess of Music and Poetry); Marichi (Goddess of the Dawn); and many others. Each Bodhisattva has a particular function and symbology.

The Y*i-dam* are tutelary deities. In Tibet each person chooses a tutelary as his special protector for life or for a particular undertaking. Classed among the Yi-dam is a particular group, the Dhyani Buddhas, with their consorts.[4] The consort (Sanskrit, *shakti*) symbolizes the female energy of the deity.

[3] These, often called Anterior Buddhas, lived and preached before Gautama Buddha. The best known is Dipankara. For more details see Chapter IV.

[4] The Tibetans call these deities "Yab Yum," meaning "Father-Mother." The male deity symbolizes "power," or the "method," while the female deity symbolizes "wisdom,"which utilizes it. The two are always in union. See p. 53 for illustration.

The *Dharmapala* are defenders of the law, the protectors of Buddhism. They are usually shown in fierce manifestation, since among their functions is the subjection of the enemies of the Faith and of evildoers.

There are a host of lesser divinities: the *Lokapala* are the guardians of the four cardinal points of the Buddhist universe; tbe *Dakinis* (sky-goers, or fairies) are invoked to grant superhuman powers. Then there are *Goddesses of the Bardo* (the period between death and rebirth), some of whom are animal or bird-headed. They appear to the deceased in visions in the after-death state. The eighty-four *Great Magicians* who were teachers and writers of the Tantric treatises also were deified. There are *Wealth Gods*, invoked and propitiated for the granting of riches; *Mountain Gods*, guardians of the wealth stored in the mountains; the *Five Kings*, who are the astrologers and protectors of the monasteries; and a host of demons, witches, fairies, heavenly musicians, serpent gods, golden birds and household, personal, and local gods, who differ in various localities.

Many of the great historical teachers, both Indian and Tibetan, were deified and taken into the pantheon. Among these are Padmasambhava, the founder of Lamaism, Atisha, Marpa, Mila-repa, and Tsong-kha-pa, founders of the later reformed sects. The group of sixteen original disciples of Buddha and two religious supporters, usually spoken of as the eighteen Arhants (Deserving Ones), were also deified and worshiped.

Many of the forms of the deities are peaceful and beautiful, while others appear angry and threatening, depending on the particular purposes for which they are invoked. There are forms called "Tantric" which have more than the usual number of heads and arms and legs. These deities may have had their origin in the primitive idea that a deity capable of doing good with two arms could multiply his powers by having four or eight or a thousand arms. The distinguished scholar the late Ananda K. Coomaraswamy, in *The Dance of Siva*, p. 70, said: "To reflect such conceptions in art demands a synthetic rather than a representative language. It might well be claimed, then, that this method adopted sometimes in India, sometimes in Egypt, sometimes in Greece, and still employed, has proved successful from the practical point of

view, of pure expression, the getting said what had to be said: and this is after all the sure and safe foundation of art.

"These forms remain potentially equally satisfactory, too, whether as philosophers we regard them as purely abstract expressions, or, with the artists themselves regard them as realistic presentations of another order of life than our own, deriving from a *deva-loka*, other than the world we are familiar with, but not necessarily unknowable or always invisible."

According to the legend in Avalokiteshvara's last incarnation as a Bodhisattva on earth, he became enlightened and ready to become a Buddha and enter Nirvana. On his way there he heard weeping and wailing. Turning about, he looked down upon the earth and saw humanity bewailing the fact that he who had helped them with his infinite compassion was about to leave them and enter Nirvana. Agonized by all this, he mourned so that his head split into pieces. The Dhyani Buddha Amitabha, his spiritual father, put the pieces together into eleven heads and gave him a thousand arms. Avalokiteshvara vowed to remain a Bodhisattva to help suffering humanity and pledged that he would not enter Nirvana until all sentient beings were saved. Avalokiteshvara is incarnate in each Dalai Lama.

If some of the images or ritual objects seem fantastic or terrifying, it must be remembered that everything has a special meaning and a complex symbolism, which in many instances goes so far back into antiquity that it is impossible to trace its origin. Every pose of the hands, every object carried, even the color and type of garment and ornament has a special significance. A ferocious aspect does not necessarily imply an evil deity; it is an aspect which a deity may assume for the purpose of terrifying evil spirits or evildoers. An example is the ferocious Yamantaka, who is but the fierce aspect of Manjushri, the God of Learning, to whom the people of Tibet appealed when Yama, the God of Death, was ravishing the country. He assumed this fierce form and conquered Yama, limiting his powers, but making him Judge of the Dead and one of the Defenders of Buddhism. These forms in general denote superhuman powers, and it is considered especially efficacious to worship them.

The symbolism is mostly of Hindu origin. The objects held in the hands of the deities, their sitting and standing positions, their garments and ornaments, and even the animals on which they sit — all have their meaning. These symbols have often been changed by the migration into other countries and the absorption of indigenous ideas into the religion.[5] The objects and their symbolism are too numerous to cite individually. A few examples are the lotus flower on which the deities sit, a symbol of divine origin; the sword in the hand of Manjushri, the God of Wisdom, a symbol which "cleaves the clouds of ignorance"; the skull cup filled with blood is a reminder of the transience of human existence. The postures were based originally on the Yoga doctrines.[6] The "adamant posture," called the "lotus posture," is the one assumed for meditation. The posture of the future Buddha, who sits in what is called "bhadrasana,"[7] symbolizes that the Buddha is ready to come to earth to preach the doctrine. The princely ornaments generally denote the calm, mild deities; the skull crowns and snake ornaments, the fierce and wrathful types.

All these forms, however, are but different manifestations of the infinite qualities of the Supreme Buddha, the First, Self-Creative, and Omnipotent Author of the Universe.

[5] See d'Alviella, *The Migration of Symbols.*
[6] Yoga means literally the act of yoking, joining. The Yoga philosophy is a system taught by Patanjali, "Its chief aim to teach the means by which the human spirit may attain complete union with Isvara or the Supreme Spirit." Concentration, meditation, and abstract contemplation are some of the disciplines and practices used to accomplish this.
[7] This is sometimes called the European posture, that is, seated with the feet hanging down.

TEMPLE PAINTINGS
(THANG-KAS)

THANG-KAS are paintings or, occasionally, embroidered pictures, usually called "banners." They first came into use about the tenth century.[1] Before that time painting was mostly confined to frescoes on the walls of temples or monasteries or in caves. Most of the *thang-kas* we see in the Occident probably date from the seventeenth century to the nineteenth century. A few are earlier, if we can judge by comparing colors and techniques.[2]

These *thang-kas* are hung in the temples and at family altars in homes. They are also carried by the lamas in religious processions. They portray a deity, groups of deities, or scenes from the life of Buddha or the saints. Often they depict stories which the lamas use to illustrate their sermons.

The banners are usually painted on canvas, sometimes on paper, but rarely on silk. The canvas is sized with one part glue to seven parts white chalk mixed with tepid water. Then it is stretched on a frame to dry. It is rubbed with a smooth stone, sprinkled lightly with water, and again left to dry. After studying under the guidance of a lama artist, the student monk prepares the canvas and puts the outline on the canvas from a transfer of dotted lines. Then the colors are made ready. At first the colors were made from minerals and vegetables. The blue and green mineral colors are ground from minerals rocks found near Lhasa. The yellow comes from the province of Khams. The reds are made of oxide

[1] The idea of these banners, or scrolls, probably came from China, as in the tenth century Peking was the center of Lamaist art. See Binyon, *Painting in the Far East*, p. 165.

[2] Among the many banners that have passed through our hands, only three had inscriptions with dates: two of Lha-mo, and one of Avalokiteshvara. See illustrations pp. 37, 45.

of mercury, and the vermillion is imported from India and China. Gold is brought from Nepal. The vegetable colors are: black, made from soot of pine wood; indigo, from the indigo plant from India; yellow, from a flower growing in the vicinity of Lhasa, the utpala flower; lac, from the lac insect of India and Bhutan.

The minerals are ground, then mixed in various proportions with water, glue, chalk, and lac or alum to give the different degrees of consistency and shading. The plants and vegetables are boiled before being prepared with the required amount of glue.

The brushes used are pine twigs hollowed at one end, into which goat or rabbit hairs are inserted to the required thickness. A compass made of two pieces of split bamboo is needed also in order to get the correct measurements of the figures on the canvas, according to the canonical rules. Usually the student does the work up to this point. The lama artist continues from there. He paints in the landscapes and figures. The important details, such as the faces of the deities and the inscriptions, are executed on auspicious days decided on by the astrologer lamas. When the painting is finished, it is mounted with a silk or brocade border, and usually a thin silk dust-curtain is put over it. Around the painting there should be a narrow red border, then a narrow yellow border, and last the wide blue mounting, in proportion to the size of the canvas. When the original mountings wear out, they are sometimes replaced by other colors. Usually there is a flat stick to which the banner is attached at the top. At the bottom there is a roller, sometimes with ornamental ends, to weight the banner and keep it straight and firm. Red, yellow, and blue are the three primal colors used in mounting the banners.

When the banner is finished, it is consecrated by a high lama. Occasionally one finds on the back the print of the hand or of the foot of a Living Buddha. The subjects and composition are often very striking and vivid, and they produce spectacular effects when seen by the light of the flickering butter lamps in the dim interiors of the temples.

These temple paintings can be classified in general into several groups. An example of each group is reproduced on pages 17–48, together with an explanation of the design and technique of each.

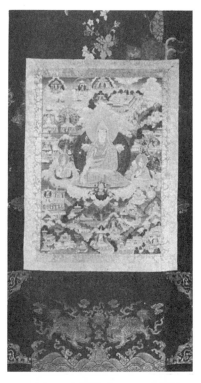

TIBETAN BANNER (FRONT)

TIBETAN BANNER (FRONT,
WITH DUST CURTAIN)

TIBETAN BANNER (BACK,
WITH HANDPRINT AND
INSCRIPTION)

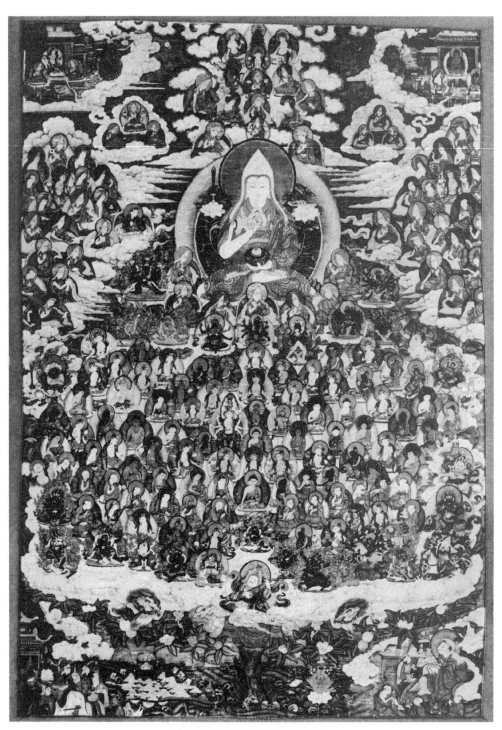

ASSEMBLAGE OF DIVINITIES

The prime purpose of these *thang-kas* is for meditation on a certain manifestation of the deity. The mind concentrates and follows through the four stages: contemplation, meditation, practice, and finally completion.

ASSEMBLAGE OF DIVINITIES (Tibetan, *Tshog shing*, Assembly Tree). The general design is that of a tree. Its roots are in the waters, and on its branches, which reach into the heavens, sit the Assemblage of the Gods. The central figure in the heart of the tree is that of Tsong-kha-pa, the founder of the Yellow Cap Sect and great reformer of Lamaism.[3] Surrounding him in rows are Buddhas, Bodhisattvas, Defenders, Tutelaries, gods and goddesses of all ranks. Above, presiding at the top, is the Adi-Buddha, Vajradhara, the Supreme Buddha of the Yellow Cap Sect. In the upper left corner, enfolded in clouds, is the Tusita Heaven, presided over by Maitreya, the Future Buddha. In the upper right corner is the Sukhavati Heaven, where pure souls are reborn; this is presided over by Amitabha, Buddha of Infinite Light. Deified saints and teachers are on each side, and all these are connected by cloud bands to their Inspirers in Heaven. This *thang-ka* is beautifully painted and probably dates from the seventeenth century.

Little is known about this type of banner. The position of the deities differs on various *tshog shing*. This may be because of different sects, since the ritual in the orthodox sect differs from that in the reformed sects. However, from the technical standpoint the Assembly trees have the same general construction. The artistic merit depends upon the lama artist.

THE WHEEL OF LIFE (Tibetan, *Srid pahi hkhor lo*, The Wheel of Transmigration). A painting of this wheel is usually found in the vestibule of Lamaist temples. The lamas say Buddha himself drew the diagram in the sand in order to explain to his disciples the Buddhist conception of life

[3] In the *tshog shing* illustrated, the central figure is Tsong-kha-pa. There are some *tshog shing* which have Gautama Buddha as the central figure.

and death and rebirth, or transmigration according to Karma, which might be called the doctrine of ethical retribution.

The wheel itself is held in the clutches of a demon who symbolizes impermanence. In the hub of the wheel are a cock, a snake, and a pig, symbolic of lust, anger, and ignorance, the three cardinal sins of Buddhism. In the rim around this hub is a narrow band, the light half showing the upward path leading to the superior worlds of rebirth, and the dark half showing the downward path leading to the inferior worlds of rebirth. Beyond this narrow band the body of the wheel is divided into six segments (sometimes five, when the World of the Gods and the World of the Asuras, or demigods, is combined). These segments depict the different worlds of rebirth.

At the top is the Region of the Gods. At the left of this is the Region of the Asuras, demigods, and at the right, the Region of Man. These are the superior worlds of rebirth. In the center below is the hell region, wherein Yama, the King of the Dead, presides over the judgment. At the left is the Region of the Animals, and at the right, the Region of the Tortured Spirits. The last three regions are inferior worlds of rebirth.

In the outer rim are twelve scenes which sometimes vary in minor details, but which Buddha called the causal nexus, the chain of cause and effect, or the reasons for transmigration.

These symbolize the various stages through which man passes from birth: ignorance, conformations, consciousness, self-consciousness, senses, contact, desire, indulgence, married life, maturity, the birth of an heir, decay and death, and then rebirth through countless existences. At each death man is reborn according to his Karma, into one or another of these six worlds, until he, like Buddha, through enlightenment reaches perfection and, no longer "bound to the wheel," passes on to Nirvana to become one with the Universal Spirit.

This, then, is a simple explanation of the "Wheel of Life." In the esoteric doctrine the metaphysical concepts are more complicated and are comprehended only by the higher lamas.

The painting of the Wheel is very complex; the profound symbology must be carried out perfectly. The joys and punishments in the six

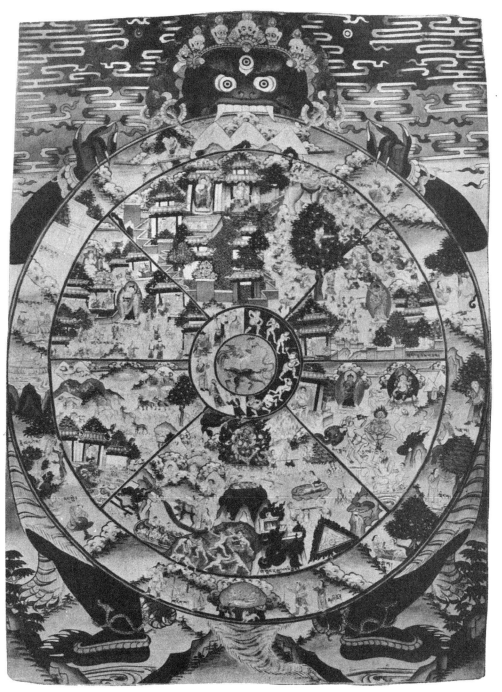

THE WHEEL OF TRANSMIGRATION

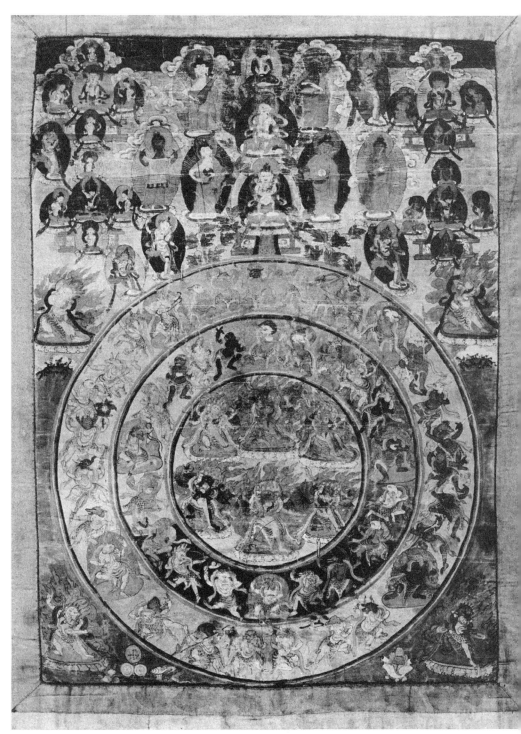

THE BARDO THÖDOL, THE INTERMEDIATE STATE BETWEEN
DEATH AND REBIRTH

regions of rebirth are vividly portrayed in miniature. In the outer rim the various incidents of the casual nexus are shown in minute detail. This particular *thang-ka* dates from about the seventeenth century. The drawing is very well done, and the coloring is excellent. It was brought from Tibet by Captain John Noel when he returned from the third Mt. Everest expedition, and was purchased by William B. Whitney. This *thang-ka* is now in the Whitney Tibetan Lamaist Collection at the American Museum of Natural History, New York City.

THE INTERMEDIATE STATE BETWEEN DEATH AND REBIRTH (Tibetan, *Bardo Thödol*, the intermediate state, or *Shi-ba Khro-bo ye dkyil hkhor*, the magic circle of the peaceful and wrathful deities). This Magic Circle is the Great Circle, showing all the principal deities who appear in symbolic visions to the dead in the short period between death and rebirth — the intermediate transitional state between death and enlightenment or rebirth into one of the six worlds of transmigration. The transitional state is believed to last for forty-nine days.[4] It is divided into three stages; the period of the realization of death, which lasts from three to seven days; the state of glimpsing reality, which lasts fourteen days and in which symbolic visions occur; and the state of seeking rebirth, which lasts for the remaining days. For the few possessed of great knowledge and yogic training, liberation may come at once, but in most cases, the deceased must pass through the *Bardo* (the intermediate state) and be reborn in accordance with the judgment into the Wheel of Life.

The symbolic visions are only hallucinations born of the thoughts constituting the personality of the deceased. At first the peaceful deities appear; then the angry and wrathful ones; and finally the various animal- and bird-headed deities. Then the soul is judged and seeks rebirth in one of the six worlds according to his Karma. This doctrine of the Bardo Thödol, as it is called in Tibet, constitutes one of the main tenets of Lamaism. In all, about 110 deities are shown on this banner, each in his prescribed ritual color, hand and foot positions, garments, ornaments,

[4] Symbolical forty-nine days.

ritual implements, physical characteristics, and expressions. The minutest details are perfectly executed.

Most of the designs on the older *thang-kas* are geometric — circles within circles. In the more recent ones (eighteenth and nineteenth centuries) the principal deity is surrounded by the lesser deities, the mild forms occupying the upper half of the *thang-ka*, and the angry and fierce forms the lower half.

MAGIC CIRCLE, OR MANDALA (Tibetan, *dKyil hkhor*). The next type of banner to be described is the one known as the Magic Circle, or *Mandala*. The design is geometric — a circle within a square and a circle. The *mandala* represents the dwelling place of the deity and his retinue. The deity himself resides in the innermost part of the *mandala*. He is invoked by the lama in accordance with the prescribed rites: by incense, offerings, and invocations. The lama identifies himself with the deity and receives from him the powers he desires.[5]

The drawing of these *mandalas* is very complicated. The colors of the deities are white, blue, red, yellow, and green, according to their canonical descriptions. Gold ornamentation is also used. The mounting (borders) are often of very fine brocade, sometimes decorated with mandarin squares.[6] Some very fine examples of this latter type, on exhibition at the American Museum of Natural History, New York City, are from the temple of Jehol, China.

HOROSCOPE, OR ASTROLOGICAL DIAGRAM (Tibetan, *dKar-rtsis-dkyil-hkhor*). Horoscopes, astrological diagrams, and charts are an essential part of a lama's equipment. There are specially qualified lamas called Tsis-pa attached to all monasteries, and Tibetans never start out on a journey or enter upon an undertaking without consulting one of these lamas, who determines whether or not the day is propitious. The predictions are based upon mathematical calculations combined with certain formulas jealously guarded by the lama astrologers.

[5] See Lessing, *Yung-Ho-Kung*, for detailed description of Shamvara Mandala.
[6] American Museum of Natural History, Whitney Tibetan Lamaist Collection.

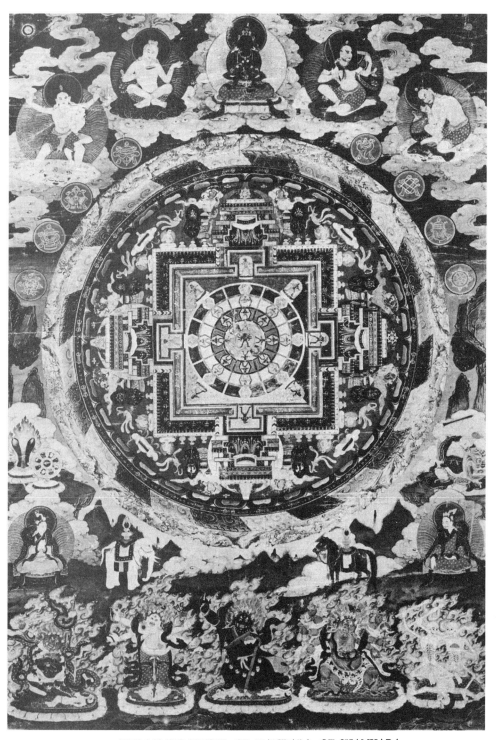

THE MAGIC CIRCLE, OR MANDALA, OF SHAMVARA

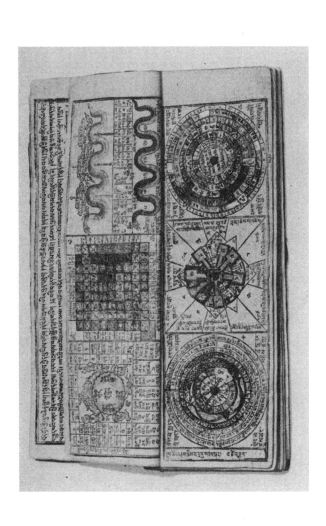

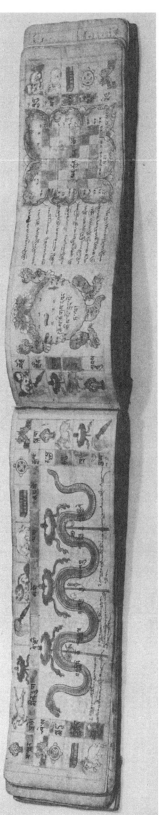

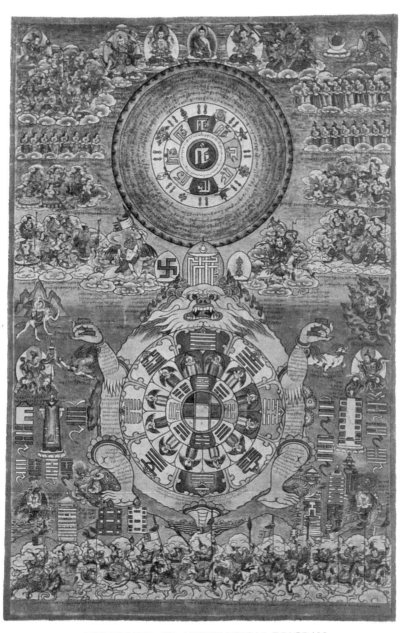

HOROSCOPE, OR ASTROLOGICAL DIAGRAM

On the *thang-ka* illustrated here the diagram is drawn on the belly of a frog. It is divided into what mathematicians call a magic square, with the numerals in nine spaces, arranged so that the sum of the three numerals in each line equals fifteen.

4	9	2
3	5	7
8	1	6

The eight segments in the circular band surrounding this contain the eight trigrams representing the eight quarters and their elements. North, for instance, is fire, red; northeast is earth, yellow; and so forth. The days of the week also have their significance. For instance, Sunday and Tuesday are fire; Monday and Wednesday, water; and so forth. Each hour of the day possesses a lucky or unlucky character, as do the days of the month also. By calculation the lama comes to certain conclusions based upon the birthday of the individual and the consequent influence of the various planets and spiritual powers.

The invention of trigrams is attributed to the legendary personage Fu-hsi, who was supposed to have lived in China about 2850 B.C. These signs were revealed to him by a dragon, a mythical animal which came one day on the waves of the Yellow River carrying the trigrams inscribed on the scales of his back. The eight mystic signs are formed by a combination of lines of two different kinds, one an unbroken line, the other a line broken into two parts, viz. — and — —. The various combinations formed by these trigrams relate to the planets and constellations, cardinal points, signs of the zodiac, elements, years, months, days, and hours; to animals, plants, members of the family, colors, lines of the hand, parts of the human body, and other details.[7]

The outer circular band is made up of twelve lotus petals colored to

[7] For further details on the trigrams, see V-F. Weber, *Ko-ji Ho-ten.*

represent the twelve cyclic animals of the zodiac. Below this are the days of the week, represented by their symbols and the planets: The sun, Sunday; crescent moon, Monday; eye, Mars, Tuesday; a hand, Mercury, Wednesday; a magic dagger, Jupiter, Thursday; a garter, Venus, Friday; a broom or a dragonhead, Saturn and Rahu, Saturday.

The side columns on the *thang-ka* show mystic diagrams invoking the stars and the planets, the rulers of the earth spirits that preside over diseases; and the diagram for drawing omens.

These horoscopes, like the *thang-kas*, are painted on canvas, silk, or paper, depending on the wealth of the family. They are kept on the family altar. The making of these horoscopes is a great source of revenue to the astrologers.

Special books called "Mo-pe" contain directions for making the charts. They contain also the mathematical formulas on which the lamas base their calculations.

Under this heading we could also put charm prints. Printed on paper or silk according to the wealth of the person, they serve many purposes — to ensure long life, to prevent illness, to acquire wealth, to ward off evil, and to procure favorable rebirth. Some are to prevent dog bites, poison, bullets, and fears of all kinds. They are made by the lamas from block prints, and when suitably consecrated are given to the layman for a fee. The charms against illness are often printed on thin paper and rolled into pills and swallowed. These are "edible charms." The other charms are carried about in the *gahu*, or charm boxes, or kept on the family altars.

PRINCIPAL EVENTS IN THE LIFE OF THE BUDDHA. The usual types of banners are those which show in the center the figure of a deity surrounded by other deities or by his retinue. Scenes from the life of Buddha or one of the great saints or teachers of Lamaism are most often depicted. First among this group are the Principal Events in the Life of the Buddha, Gautama, the founder of Buddhism.

The twelve principal events as described in the Lalitavistara, a part of

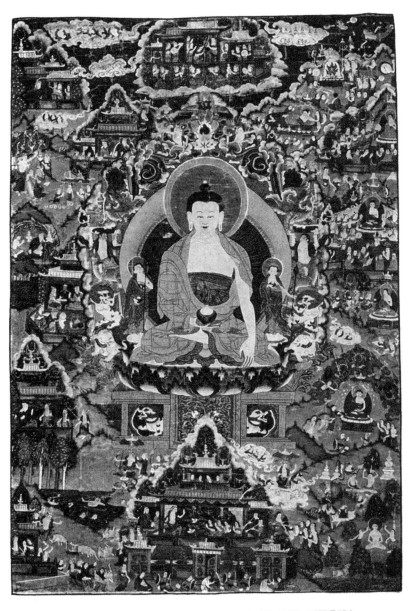

PRINCIPAL EVENTS IN THE LIFE OF THE BUDDHA

the Tibetan canon, are pictured here. The story connected with it is as follows.

The future Buddha is seated in the Tusita Heaven awaiting his time to come to earth to reveal the doctrine. The white elephant, a symbol of the miraculous birth of a great teacher, is near by. Queen Maya, wife of King Suddhodana, dreams that the white elephant enters her womb and she conceives. The Buddha is born in the Lumbini gardens, from his mother's right side. The gods and goddesses appear to bathe the newborn babe. The Buddha walks seven steps in each direction and pointing upward says, "Now for the last time am I incarnate." Maya dies seven days after the birth of the Buddha. Shortly afterward Asita, a sage, asks King Suddhodana for permission to see the babe. Asita recognizes the thirty-two marks and the eighty physical perfections of a Buddha and deplores the fact that he will not be in the world to witness the "awakening of the Buddha."

The young prince, Gautama Siddhartha by name, is brought up in luxury, and when the time comes for him to marry, all the eligible maidens from the surrounding districts are invited to come to the palace. At the sports events Siddhartha surpasses all the princes. He chooses Yasodhara, the daughter of a neighboring prince, for his bride. Then, for a time, comes "life in the pleasure palace." His father had built the palace for him in the hope that its joys would cause him to cease brooding on life and its meaning and prevent him from seeing any unhappy or unpleasant sights outside the guarded palace. However, the time comes when by accident, or perhaps by the design of the gods, he sees an old man, a sick man, and a corpse. Asking Channa, his charioteer, for the meaning of these things, Channa replies that all things grow old and die. Gautama decides that the time has come for him to leave the palace and start the search for truth.

One night, while the palace is asleep, he leaves his home. When he reaches the forest, he cuts off his hair and gives away his princely jewels and garments. Henceforth he lives the life of a wandering ascetic, going from teacher to teacher and preaching to the forest people, the animals, and the *nagas* (snakes). At last, one night under the Bodhi tree, Mara, the

tempter, comes to him and tries to persuade him to renounce the ascetic life and return to his family. He overcomes the temptations which Mara brings him and, pointing to the earth, asks it to bear witness that he has overcome Mara, "The Evil One." Then, sitting all night under the Bodhi tree and meditating, he first sees the line of all his past lives; secondly, he obtains insight into the cosmos, the world, the suns, and time; thirdly, he learns the Secret of Sorrow and the four Noble Truths; and fourthly, the Way of Deliverance. This is "The Enlightenment."

The *thang-ka* illustrated depicts the foregoing incidents and also the following, which took place after the Enlightenment: the first sermon (Turning the Wheel of the Law), the death of Buddha (The Parinirvana), and the disposal of the relics.

Sometimes the twelve events are on one banner, as in this illustration. Often there is a group of eight banners, each having a central figure of Gautama in one of his various attitudes and showing in more detail the important events of his life.

In this group would also be classed the "Jataka" banners.[8] These show the many former lives of the Buddha and his different rebirths, before he reached the stage of his last birth in the mortal world and attained Enlightenment.

LHA-MO, THE GLORIOUS GODDESS. This goddess, whose Sanskrit name is Shri-devi, but who is better known in Tibet as Lha-mo, is the only feminine divinity among the Dharmapala, the Defenders of the Faith. She has a mild aspect, called Ma-cig dpal Lha-mo (seated center in oval, just below the feet of the mule). Usually, however, she is shown, as in this banner, in a fierce form, as a powerful destroyer of the enemies of the faith. She also is a manifestation of time, symbolized by the goddesses of the four seasons emerging from her hair. She is the powerful protectress of the Religion and the Patron of both the Dalai and the Tashi lamas.[9]

[8] There is a group of thirty-one banners showing all the incarnations and various incidents in the former lives of the Buddha. This set of banners is in the collection of Roland Koscherak, New York City.
[9] See pp. 12,57 for explanation of the tantric deities.

This *thang-ka* showing Lha-mo and her retinue is an especially fine example. It is also unusual in that it is dated. The inscription below reads: "Made by command of the Emperor Chien Lung in the 42nd year of his reign," which corresponds to A.D. 1777. When examined through a magnifying glass all the figures of the jewel goddesses and other members in the retinue may be identified, with all their symbols and ornaments. The Tibetan invocation at the top reads:

To the Glorious Kali, the great Goddess,
[Thou who art] the powerful lady of an army and weapons
With both she of the lion's face and she of the makara face,
[One] following from behind and one leading from before,
Thou, who subduest the doers of evil deeds and mitigates them
And from everywhere, increasing the good deeds,
Hast gathered in thy power, from all quarters, a complete victory,
Thou who hast subdued, by thy fierce aspect, all the dangerous
 enemy evil spirits,
Indeed, these are the four functions of Lha-mo [Goddess of
 Karma],
Thou, Lha-mo, by magic transformations
Takest on secret forms[10]
And the Four Seasons emerging from the dark vortex of [thy]
 crown,
Who are all-powerful in regard to Time, Spring, Summer, Autumn,
 and Winter,
Thou art the greatly auspicious Glorious Goddess
Who performest perfectly the Five Transformations.
Lha-mo, Auspicious One, [of] the Five Long-Life Sisters;
She of Long-Life; She of the Beautiful Blue Face;
She, the Unagitated One; She of the Five-Leafed Crown and
 Beautiful Neck;
 She, Who Bestows Perfection on those of virtuous behavior.
 Thou, Lha-mo, art the incarnate being of the highest excellence.

[10] She assumes secret forms for the protection of her devotees.

Together with the twelve Jewel Goddesses, Great Doctrine
 Protectors:

The All Famous Jewel

The Disease Protector Jewel

The All Good Jewel

The Mistress of Obstacles Jewel

The One-eyed Jewel

The Noble Mother Jewel

The Serpent Jewel

The Renown Queen Jewel

The Realm Defender Jewel

The Medicine Jewel

The Stain Remover Jewel

The Elegant Form Jewel

[Thou] Lha-mo, Mistress, and twenty-nine of the retinue,[11] all
 assembled Who possess the Four Great Secrets.

The original essence of truth [according to the transcendental
 teaching] is that phenomena [manifested things] are not real,
 [while the mundane teaching is] that noumena [unmanifested
 things] are real. Such is the nature of the mind.[12]

May the truly sovereign doctrine increase

For the protection of the entire realm.

Heaven Protector, forty-second year, sixth month.

By order of the King, it is made.

[11] The twenty-nine in the retinue comprise: the three presiding Buddhas with
their shaktis (6): Makaravaktra and Simhavaktra (2); Jewel Goddesses, (12);
Long-life Sisters (5); The Seasons (4).

[12] The Chinese text of the paragraph above, freely translated, reads: "The
visible is identical with the invisible." The Manchu text: "Although we see the
various shapes they are non-shapes." The Mongolian text: "The various shapes
by their very natures are nonshapes." This is the doctrine of the void, or
Shunyata. Arthur Avalon in the Shricakrasambara Tantra, p. XXXIII, says
"Universe and Nirvana are not two but one or Shunyata. Just as the mind and
body in any individual are aspects of one unity." According to the Prajnapara-
mita sutra, "Form (rupa) or matter is the void, and the void is form. The one is
not other than the other."

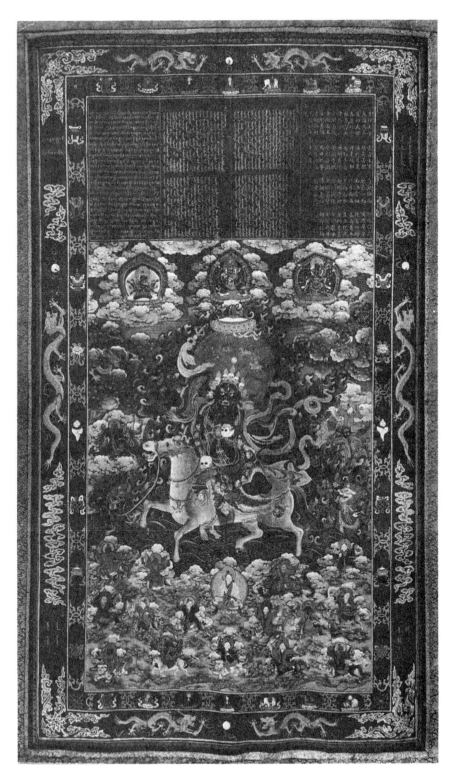

LHA-MO, THE GLORIOUS GODDESS

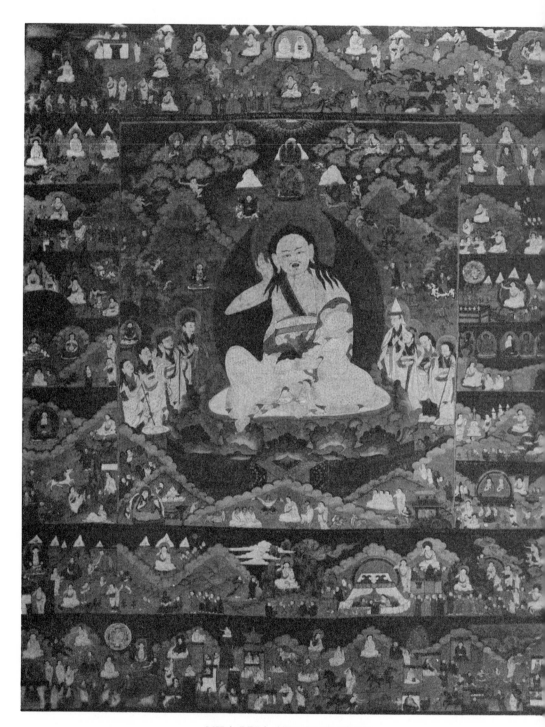

MILA-REPA, THE POET-SAINT

On the back of this *thang-ka* is an inscription which reads:

> The forty-second year, twenty-fourth day of the month, of the
> reign of the Heaven Protector (Chien Lung).
> By command to the Changcha Hutuktu to draw the images ac-
> cording to the doctrine.
> [Of] the Queen Rimati, possessing a powerful army of weapons.
> [In her] retinue both [she] with the makara face and [she] with the
> lion's face.
>> Lha-mo and the Four Seasons,
>> Macig dpal Lha-mo
>> The five great Long-Life Mothers
>> The twelve Guardians of Precious Law
>> Altogether complete.

> And these images, radiating the brightness of the blessed [ones]
> are of very marvelous and great strength; many works can be
> accomplished [by their virtue]. They are to remain as offer-
> ings of reverence.

MILA-REPA, THE POET-SAINT (Tibetan, Mila-raspa, Mila the Cotton
Clad). Some scenes from the life of Mila-repa, the poet-saint, are shown
on this *thang-ka*. It is beautifully painted, with much minute detail, and
reveals Indian influence.

Mila-repa (A.D. 1038 — A.D. 1122), the hermit-poet, is the best-known
and most romantic character in Tibetan history. He was a disciple of
and successor to Lama Marpa, the Tibetan exponent of the semi-re-
formed Kar-gyu-pa Sect. Mila-repa is known as the "Great Yogi." The
story of his life is one of the great Tibetan epics. He studied under
various *gurus*, wandered about the country, meditated in caves, and
subsisted on a diet of nettles, which gave his skin a greenish hue. His
book, *The Hundred Thousand Songs*, is known to all Tibetans.

On this *thang-ka* Mila-repa is shown in his characteristic attitude, with
his right hand cupped behind his right ear, as if listening to the sounds
of solitude. Grouped about him are various pundits and lamas who came

to pay him homage and to listen to his teachings. Around him also are scenes from his life, depicting the magic he wrought and incidents of his teachings. These are meticulously painted; they show the influence of Indian miniature paintings. Unfortunately there is no clue as to the date.

As poetry comes under the heading Art, it may not be inappropriate to give an excerpt here from one of his poems.

> Chags med zen med rmongs med gsum
> Adi gsum sems kyi go cha lags
> Gyon na yang la mtshon khar sra
> Go cha mdsad na de la mdsod

Freely translated it reads:

> Freedom from passion, freedom from desire,
> Freedom from folly [are] three;
> These three are the armor of the soul
> In donning this armor you are invulnerable.
> Fashion this armor, and act accordingly.[13]

TSONG-KHA-PA, THE MAN FROM TSONG (Tibetan, *Lob-zang grags-pa* or *Je-rin-po-che*, the Renowned Lob-zang, or His Precious Reverence). This *thang-ka* is beautifully executed. The painting is similar in technique to Nepalese miniatures.[14]

On this *thang-ka* he is shown in the usual monastic garments and pointed hat of the Yellow Cap Sect. He holds in his hands the symbolical sword and the book. The sword is the means by which "he cleaves the clouds of ignorance," and the book is the "Book of Transcendental Wisdom." These two symbols are those of Manjushri, the God of Wisdom, of whom Tsong-kha-pa is believed to be an incarnation. He is accompanied by his two chief disciples. Presiding over the *thang-ka* are figures of various Buddhas, from whom he received his inspiration, and

[13] From poem No. 23 of the "Songs of Mila-repa," translated by the author.
[14] This *thang-ka* was brought from China by William Hagen, who was American Vice Consul at Yunnan Fu at the time.

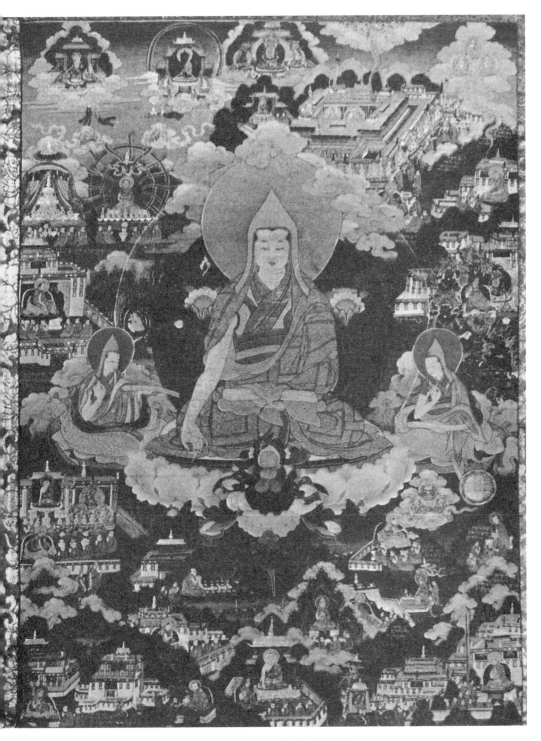

TSONG-KHA-PA, THE REFORMER

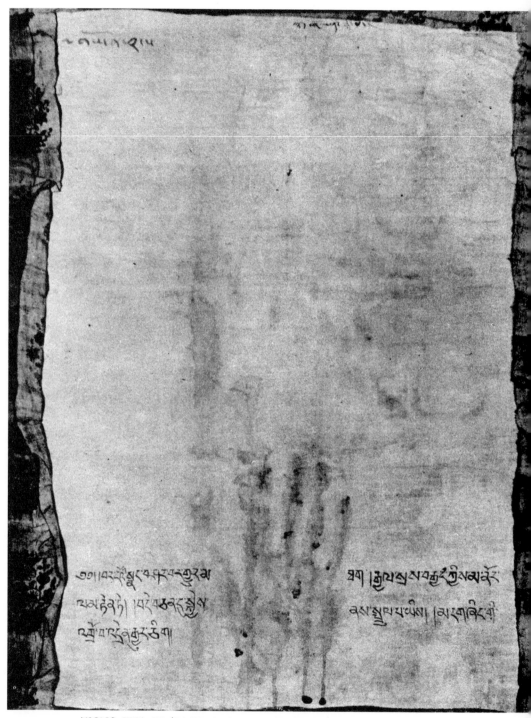

TSONG-KHA-PA (BACK, SHOWING INSCRIPTION AND HANDPRINT)

the rest of the banner depicts scenes from his life and preachings, visions of paradise, and many gods.

On the back of this *thang-ka* is an impression in reddish ink or paint of the hand of the "Living Buddha" who consecrated it and an inscription, a translation of which follows:

བར་ རྡོའི་ སྣང་ བ་ འཤར་ བར་ གྱུར་ མ་ ཐག

Bar dohi snang ba shar bar gyur ma thag
Bardo of brightness dawning turning now

རྒྱལ་ སྲས་ བརྒྱད་ ཀྱིས་ མ་ ནོར་ ལམ་ རྟེན་ ཏེ

rgyal sras brgyad kyis ma nor lam rten te
King sons eight of infallible way adhering to

བདེ་ བ་ ཅན་ དུ་ སྐྱེས་ ནས་ སྤྲུལ་ པ་ ཡིས

bde ba can du skyes nas sprul pa yis
Dewacan in born magic body by

མ་ དག་ ཞིང་ གི་ འགྲོ་ བ་ འདྲེན་ གྱུར་ ཅིག

ma dag zing gi hgro ba hdren rgyur cig
impure Earth of beings guide direct may

Now that the clear light of the Bardo begins to dawn,
Adhering to the infallible Path of the Eight Bodhisattvas,
May [I] be reborn in Dewacan [and] by the magic transformation body,
Guide and direct the beings of this impure Earth.

The translation of the inscription is a difficult process. Religious texts and mantras are often abbreviated, and one must supply the missing words and ideas. The first translation is a literal one, then we try to get the religious significance and put it in a smoother English. It is best, however, to keep the feeling as close as possible to the Tibetan.[15]

[15] Sir William Jones, the founder of the Asiatic Society of Bengal (1784), a fluent linguist, said: "I have ever considered languages as the mere instruments of real learning, and think them improperly confounded with learning itself."

This is a very rare and interesting *thang-ka* and is considered especially sacred because of the imprint of the hand of a Living Buddha.

AVALOKITESHVARA, THE GOD OF MERCY: The All-seeing Lord (Tibetan, *Chen-re-zi*). This *thang-ka* is extraordinary. Instead of the usual painting, this entire *thang-ka* is embroidered on silk and represents the finest example of Chinese workmanship. It is embroidered with colored silk threads and gold and silver paper threads. Fine silk cord is used to outline the halo around the central figure. The colors and the symbols are all according to ritual.

Accompanying this *thang-ka* is an inscription (also embroidered) in Tibetan, Chinese, Manchu, and Mongolian characters, which gives a command and a date. The command is "that worship is to be performed to the embroidered image of Chen-re-zi, the eleven-faced God of Mercy." The date is the forty-third year, fourth month, twenty-third day of the reign of Chien Lung (1736–1796), the Protector of Heaven (Emperor of China). This, in our chronology, would be about the year 1778. It is one of the rare *thang-kas* that has a date. It is probable that it was made especially as a votive offering to the Imperial Temple in Peking or as a gift to the emperor. The Emperor Chien Lung, his mother, and many of the court were ardent Buddhists, as the many gifts to the temples of Yung Ho Kung and Jehol amply attest.[16]

MOUNT SUMERU, THE CENTER OF THE BUDDHIST UNIVERSE. This sacred mountain is surrounded by the Eight Buddhist Symbols and the Seven Jewels of a Universal Monarch. Just below the cloud bands are the sun and the moon and the constellations. At the base are the oceans and the mountain ranges. Among the oceans are the four different types of continents or worlds, squares, circles, crescents, and forms "like the shoulder-blades of a sheep." This last one is Jambudvipa, our continent.

[16] This remarkable piece of embroidery belongs to the Metropolitan Museum of Art, New York City. It has never before been published or exhibited. The author is extremely grateful to Miss Pauline Simmons, Associate Curator of Oriental Art, for her kind permission to use this reproduction.

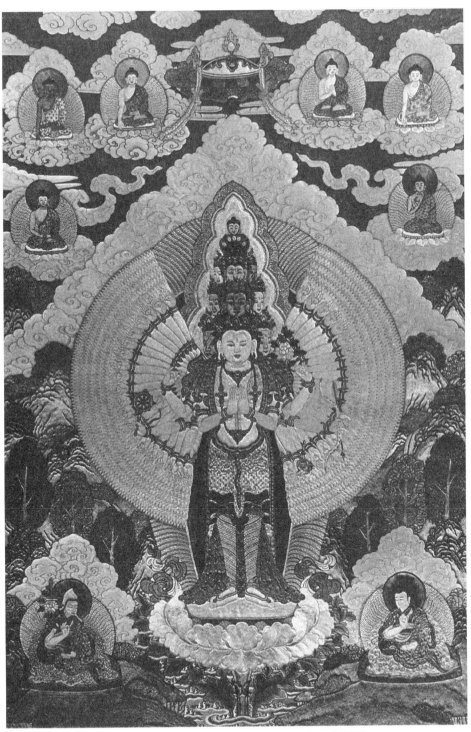

AVALOKITESHVARA, THE GOD OF MERCY

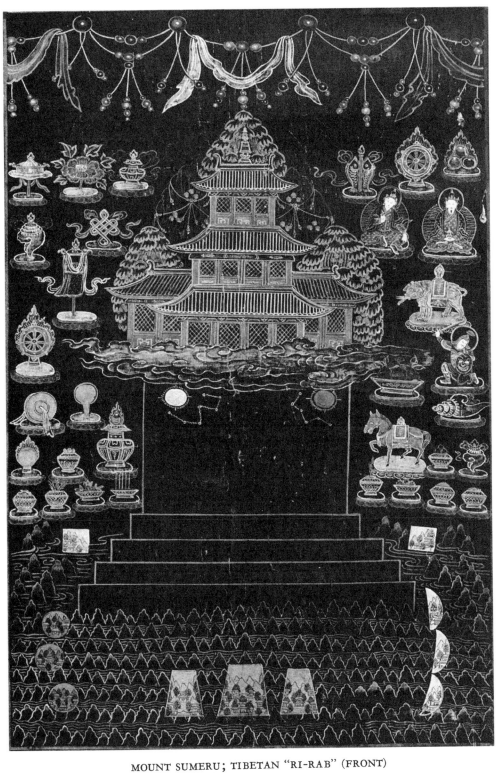

MOUNT SUMERU; TIBETAN "RI-RAB" (FRONT)

MOUNT SUMERU; TIBETAN "RI-RAB" (BACK, SHOWING INSCRIPTION)

On the back there is the Buddhist Creed, written in Sanskrit in Tibetan characters. Below are a transliteration of the traditional Buddhist interjection and a free translation of the creed.

<div align="center">

om

ri rab

glin bzi

</div>

[Buddhist Creed]: ye dha rma **ah** he tu phra

<div align="center">

bha va he tu n te sha tha ga to

hya va da ta te shan **h** yo ni rodha e vam bha

u

di ma ha *m* sra ma nah

Om ah hum!

</div>

Of all objects which proceed from a cause
The Tathagata[17] has explained the cause;
And he has explained their cessation also.
This is the doctrine of the Great Teacher.

The banners illustrated serve to show the composition, techniques, and symbolism of Tibetan paintings. It has been pointed out before that Tibetan art is almost wholly a religious art. The subjects are religious; most of the objects were used for religious purposes and were made in the lamaseries by the monks. The rules for techniques and colors as well as proportions are prescribed by the sacred books, to the smallest detail.

[17] The *Tathagata* is an epithet for the Buddha (Sanskrit). It means literally: "He who comes and goes in the same way" (as the Buddhas who preceded him). — Monier-Williams, *A Sanskrit-English Dictionary*.

IMAGES

IMAGES are made of various materials. They can be of gold, silver, copper, or bronze; or they can be of stone, wood, clay, butter, or agglomerated materials, such as juniper dust mixed with clay. They are often studded with turquoise, corals, and pearls.

Images are either sculptured by hand, made by the "lost wax method," or made in molds and finished by hand. *Cire perdu* is the "lost wax process." The object is modeled in wax, then covered with sand which is held together by a binder, such as silicate and plaster or a similar substance, and baked. This melts the wax and leaves the mold. The metal is then poured into the cavity. When the metal is set, the mold is destroyed and the figure finished by hand with a chisel and tools. By this method only one object can be made from a mold. A cavity is always left in the image, generally at the back or base, and when the artist has finished, the image is consecrated by the recitation of prayers and the insertion into the opening of relics and "dharani," magic invocatory formulas printed on rolls of paper. The opening is then sealed, and the image becomes sacred.

The following is a specimen of the procedure for the invocation and worship of the deity.[1] Gautama Buddha in *vajrasana* (adamant posture) and displaying the *bhumisparsa* (earth witness *mudra*) is to be meditated on in the following manner: "The worshipper should meditate on himself as [Vajrasana] who displays the Bhusparsa mudra in his right hand while the left rests in his lap; who is dressed in red garments and sits on the Vajra on a double lotus placed on the four Maras [directions or quarters] of blue, white, red and green color; who is peaceful in appearance and whose body is endowed with all the major and minor auspicious marks."

[1] See Bhattacharyya, *Indian Buddhist Iconography*, Pl. XIII A.

SEATED BUDDHA

From Kufusaku, *Zozo Ryodo-Kyo*

HEAD OF BUDDHA AND HEAD

OF BODHISATTVA

From Kufusaku, *Zozo Ryodo-Kyo*

STANDING BUDDHA

From Kufusaku, *Zozo Ryodo-Kyo*

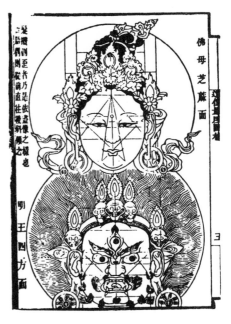

HEAD OF BODHISATTVA AND

HEAD OF DHARMAPALA

From Kufusaku, *Zozo Ryodo-Kyo*

The first images were said to have been brought into Tibet in the seventh century by the two wives of the king, Srong san gam-po. Both of these princesses, one a Chinese princess and the other a Nepalese princess, were ardent Buddhists. They converted the king to "The Religion." Later, he sent to India for images and sacred books. For that reason the early images were usually in the Nepalese or Indian art tradition. The Nepalese craftsmen were especially fine metalworkers. Most of the images were cast in bronze. Some were of silver, and a few rare ones were of gold. Wood and ivory were perishable and, therefore, used only occasionally, so that few old specimens exist.

The metal images were cast in molds and finished by hand. The process of fashioning the various deities and the rules and regulations are all described in the sacred books, which accounts for the uniformity of many of the images. The dimensions, the expressions on the faces of the deities, the number of heads and arms and legs, the symbols carried, and the attitudes are all specified in the "Sadhanas" which are the formulas for invoking the deities.

In spite of the canonical restrictions, however, the images show a wide range of imaginative interpretation due to the genius of the individual artists. They worked anonymously for the glory of "The Religion" and were often able to overcome the limitations of primitive techniques and scarcity of materials.

The formulas usually contain a description of the deity. For example, Vajradhara is a Supreme Buddha, and as such he is shown in this attitude: legs locked, soles visible, hands crossed in the hand position (*mudra*), symbolizing supreme power and holding lotus flowers which support the bell and the thunderbolt at his shoulders. He wears a crown and princely ornaments and garments.

The Buddhas of the Past, the Present, and the Future, the Medicine Buddhas, and the Confession Buddhas are usually shown in meditative attitudes. They wear no jewels, only a robe draped over the left shoulder, leaving the right shoulder bare, in emulation of the Buddha, who renounced all material things when he left his home and family. Their hand positions *(mudras)* differ; one displays charity, another preaching,

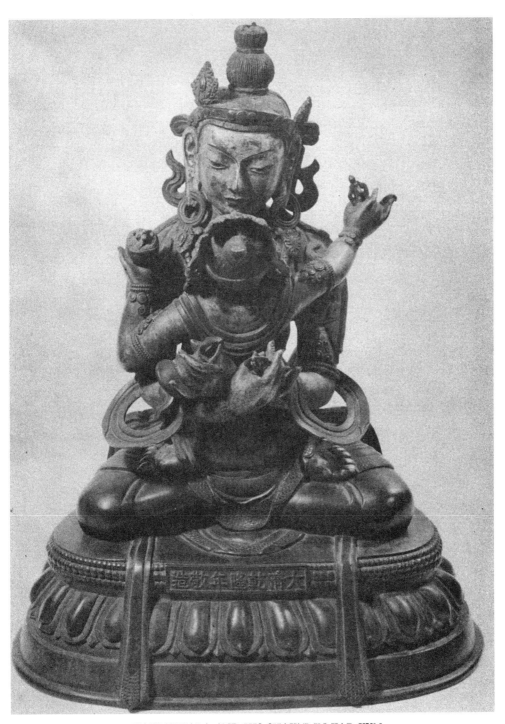

VAJRADHARA AND HIS SHAKTI IN YAB-YUM

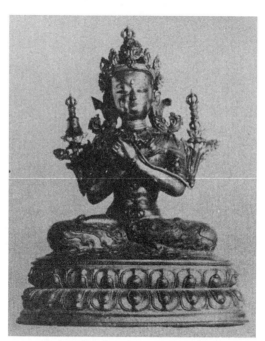

VAJRADHARA, THE ADI BUDDHA

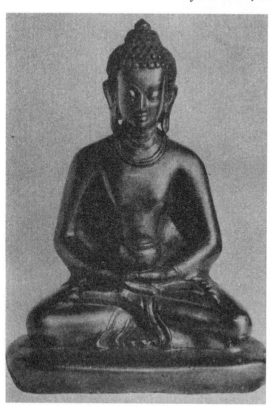

AMITABHA, THE BUDDHA OF
INFINITE LIGHT

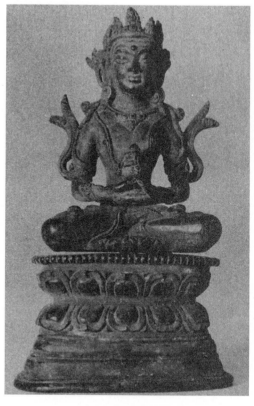

AMITAYUS, THE BUDDHA OF
INFINITE LIFE

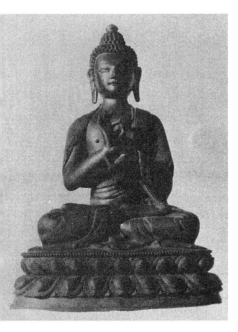

DIPANKARA, PAST BUDDHA

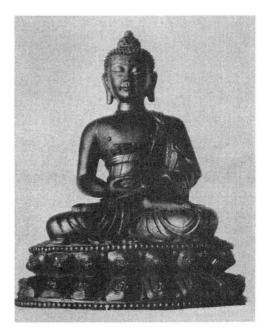

SAKYAMUNI, THE HISTORIC BUDDHA

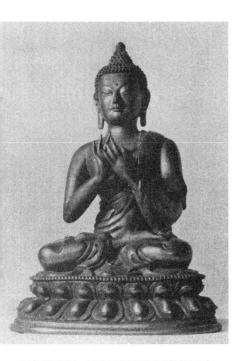

MAITREYA, THE FUTURE BUDDHA

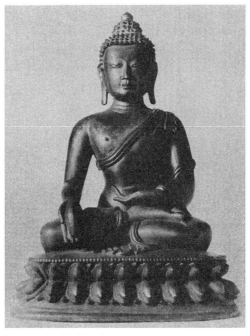

BHAISAJYAGURU, THE MEDICINE BUDDHA

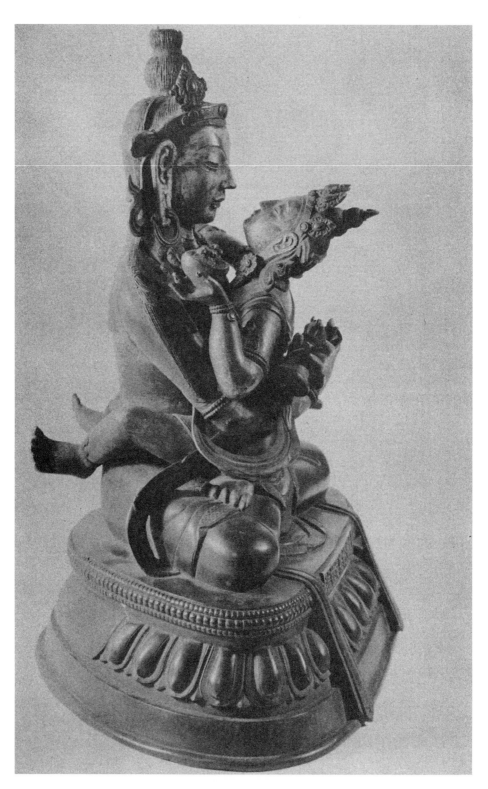

VAJRADHARA AND HIS SHAKTI IN YAB-YUM (SIDE VIEW)

another teaching, and so forth. Their colors and the colors of their halos, also differ, depending on the group to which they belong.

The Bodhisattvas ("Bodhisattva" means "essence of wisdom"), both male and female, wear princely garments and jewels. Their robes and symbols are sometimes polychromed or engraved. The deities with multiple heads or faces and many arms and legs are amazing and beautiful examples of casting and finishing. Notice, for example, the image of Ushnishasitatapatraparajita[2], whose name signifies the "Victorious white Umbrella Goddess of the Ushnisha."[3]

The Yi-dam are the tutelary deities. They are mostly tantric forms (one head and more than two arms or more than one head and two or more arms). The modeling and casting are often very complicated, especially in the images of the Dhyani Buddhas with their consorts. These images are called Yab-Yum, and are classed among the Yi-dam. In Tibetan the word "yab" means the honorable father, and the word "yum," the honorable mother. Yab-Yum, therefore, is the honorable father in the embrace of the honorable mother. The union of the two signifies the "method" and the "means" of attaining Nirvana by the merging of compassion and knowledge.[4] These striking images symbolize some of the most metaphysical concepts of "The Religion."

The Dharmapalas are the protectors of the law (dharma), the doctrine of Buddha. Therefore, their forms are usually fierce and forbidding. The forms at times are very complex, as are, for example, the Yamantaka illustrated on page 60. He has nine heads, thirty-four arms, and sixteen legs. He steps on animals and birds and Hindu deities. The casting of a figure of this type is extremely difficult. Generally the main figure and

[2] See illustration of Ushnishasitatapatraparajita, p. 64.
[3] "Ushnisha" is the protuberance on the top of the head of a Buddha.
[4] The concept of "Shunyata," or the "Realization of the Void," is one of the basic tenets of the Vajrayana System. According to Arthur Avalon (*Shrichakra-sambhara Tantra*, p. XIV), "Shunyata (*Shes-rabs*) is associated with Karuna (*Thabs*). The latter is the Power, Means (*Upaya*) or Method by which anything is done as compared with *Shes-rabs*, the wisdom (*Prajna*) which guides and utilizes it. *Shes-rabs* (Prajna) utilizes *Thabs* (Upaya) in order that Nirvana may be attained." "Wisdom is regarded as female and Power or Method as male."

the *shakti* are cast separately and attached later. The various symbols are sometimes cast separately and put in later by hand. The stand is cast, and the completed figure is inserted by means of pins.

In the illustration on page 60. there is an extremely interesting figure of Lha-mo and her two attendants. The figure of Lha-mo is cast together with the mule. The base is cast separately, as well as the two acolytes, Makaravaktra and Simhavaktra. The acolytes are then inserted into the base with pins.

Lha-mo is usually represented in her ferocious manifestation, although she has a mild one also. The Goddess, as stated earlier, is the only female deity of the Dharmapala group, the Defenders of the Faith. Legend says that Lha-mo was the wife of the King of the Yaksas (demons) in Ceylon. She tried to convert him to Buddhism and made a vow that if it were impossible to do so she would kill her own son or extirpate the royal race. Failing to convert the King, she killed her son, drank his blood, and ate his flesh. She fled, and the King, shooting an arrow after her, pierced the haunch of her mule. Pulling out the arrow, she said: "May the wound of my mule become an eye large enough to overlook the twenty-four regions, and may I myself extirpate the race of these malignant kings of Ceylon!"[5]

Lha-mo is usually accompanied by two Dakinis (Sky-Goers), Makaravaktra (she with the head of a *makara*, sea monster), and Simhavaktra (she with the head of a lion). When worshiped as the Goddess of War, Lha-mo is differently represented. The *sadhana* describes this goddess as dark blue or black and as having a very ferocious appearance.

Other illustrations are Yama and Yamantaka. Yama, the Lord of Death, became judge of the dead in this way: "There was once a holy man who lived in a cave in deep meditation for fifty years, after which he was to enter Nirvana. On the night of the forty-ninth year, eleventh month, and twenty-ninth day, two robbers entered the cave with a stolen bull, which they proceeded to kill by cutting off its head. When they discovered the presence of the ascetic, they decided to do away with him as

[5] Getty, *The Gods of Northern Buddhism*, p. 150.

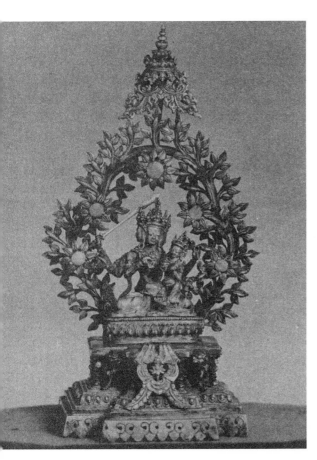

MANJUSHRI, THE GOD OF WISDOM,
AND HIS SHAKTI

MARICHI, THE GODDESS
OF THE DAWN

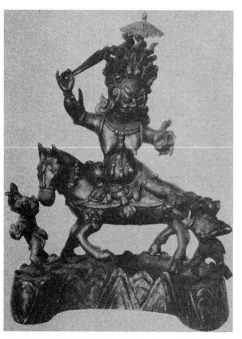

LHA-MO AND HER TWO ATTENDANTS

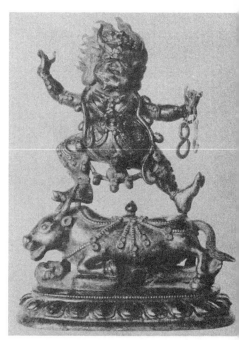

YAMA: THE LORD OF THE DEAD

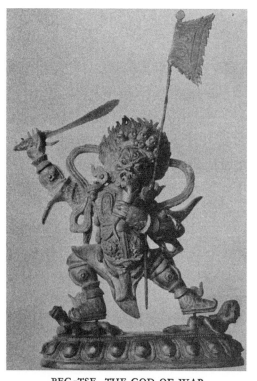

BEG-TSE, THE GOD OF WAR

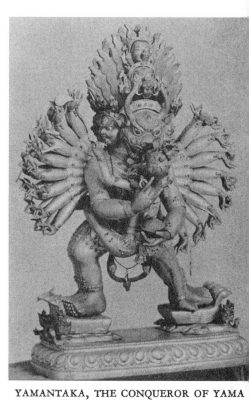

YAMANTAKA, THE CONQUEROR OF YAMA

witness of their theft. He begged them to spare his life, explaining that in a few moments he would be entering into Nirvana and that if they killed him before that time he would lose all the benefit of his fifty-year penance. But they refused to believe him and cut off his head, whereupon his body assumed the ferocious form of Yama, King of Hell, and taking up the bull's head, he set it on his own headless shoulders. He then killed the two robbers and drank their blood and made cups of their skulls. In his fury and insatiable thirst for victims, he threatened to depopulate the whole of Tibet. The Tibetans appealed to their tutelary deity, Manjushri, to protect them from this formidable enemy, whereupon he assumed the ferocious form of Yamantaka and waged war against Yama. A fearful struggle ensued, in which Yamantaka (literally, he who conquers death) was victorious."[6]

Yamantaka is shown with nine heads, thirty-four arms, and sixteen legs. According to Grünwedel,[7] the significance is this: When Yama was ravaging Tibet, he built himself a fortress with thirty-four windows and sixteen doors. Yamantaka laid siege to the fortress, closing all the windows and doors with his arms and legs and held Yama prisoner. He preached the doctrine of Buddhism to Yama until Yama became converted. Thereupon, Yamantaka made him one of the Defenders of Buddhism, Judge of the Dead and Lord of Hell. Yamantaka is represented naked and black, his chief head that of a bull, and the top head that of Manjushri, the God of Wisdom, of whom he is the ferocious aspect.

DESCRIPTIONS OF PICTURED IMAGES AND LEGENDS

KALACHAKRA, THE LORD OF TIME, WITH HIS CONSORT. Gilt bronze, $10\frac{1}{4}''$, set with turquoise and carbuncles. This complicated image is most unusual. The Lord of Time has four faces and twenty-four arms, each holding its appropriate symbol. The consort has four faces and eight arms, also holding various symbols. He steps on demons. The figures are cast

[6] Pander, *Das Pantheon des Tschangtscha Hutuktu*, p. 61.
[7] Grünwedel, *Mythologie des Buddhismus in Tibet und der Mongolei*.

in gilt bronze. Note the facial expressions and the delicate beauty of the intricate symbols.

JAMBHALA, GOD OF WEALTH. Gilded bronze, $4\frac{5}{8}''$. This corpulent figure is known as the Black Jambhala. He holds in one hand a bowl of jewels and in the other a mongoose vomiting jewels. It is exceptionally well modeled and gives the impression of strength and massiveness despite its smallness.

SHAMVARA, BEST HAPPINESS. Gilded bronze, $6\frac{1}{4}''-7''$. Shamvara and his consort. Shamvara has three heads and ten arms and holds his consort in embrace. She has one head and two arms. He stands on figures of demons. The hands hold various symbols. Shamvara and his consort are the deities worshiped by the lamas for the attainment of "*siddhi*," super-normal powers. He is shown here in his fierce form, which is powerfully expressed in this image.

MAHAKALA, THE GREAT BLACK ONE. Gilded bronze, $8''$. He has many forms; in this form he has four arms and four faces and stands on a demon. His origin is doubtful; some authorities maintain that he is derived from India, a form of Shiva. He is a popular divinity in Mongolia. Mahakala is shown here in fierce attitude with open mouth and bared fangs. Note the hair in flame halo.

USHNISHASITATAPATRAPARAJITA. Bronze, $12''$. This remarkable image of the Victorious Goddess of the White Umbrella is represented with "a thousand heads and a thousand arms." The central face, which the *sadhana* describes as "slightly distored by anger," is eloquently modeled. According to F. D. Lessing,[8] "she expels all diseases from the five senses and the bones, annihilates all sins, subdues demons and removes obstacles, protects travellers and breaks evil spells, conquers all kinds of calamities and stops war and strife. Her thousand faces, arms and feet symbolize her omnipresence, omniscience, and resourcefulness in helping mankind."

[8] Lessing, *Yung-ho-Kung.*

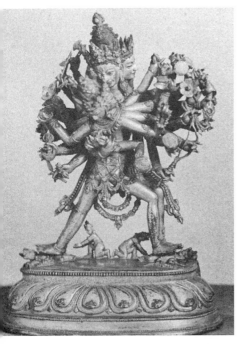

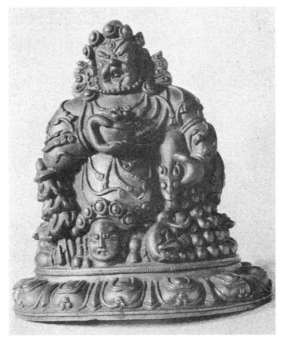

KALACHAKRA, THE LORD OF TIME

JAMBHALA,
A GOD OF WEALTH

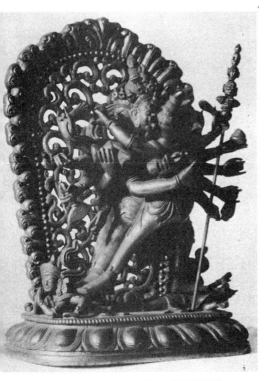

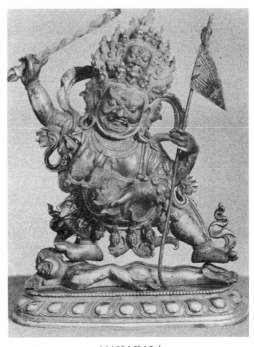

SHAMVARA, GOD OF HAPPINESS

MAHAKALA,
THE GREAT BLACK ONE

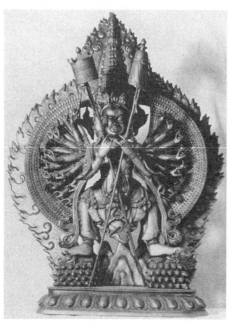

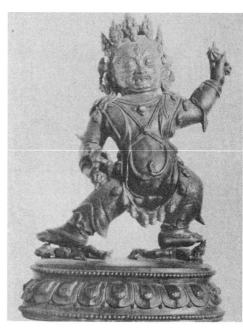

USHNISHASITATAPATRAPARAJITA,
THE VICTORIOUS GODDESS
OF THE WHITE UMBRELLA

VAJRAPANI,
THE DEMON QUELLER

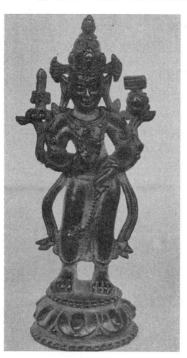

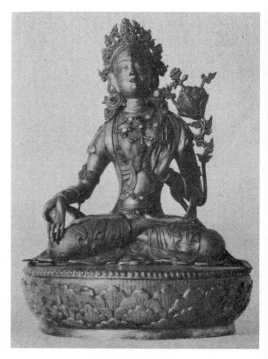

MANJUSHRI,
THE GOD OF WISDOM

WHITE TARA,
THE WHITE SAVIORESS

VAJRAPANI. Bronze with gilding, 8″. This deity has many forms. In this fierce aspect he is known as the "Demon Queller." He wears snake ornaments and a necklace of human heads.

MANJUSHRI, THE GOD OF WISDOM, Bronze, 5½″ high. At his shoulders are his particular symbols, the sword and the book of Wisdom. His expression is calm and serene exactly as the *sadhana* describes him.

WHITE TARA, THE WHITE SAVIORESS. A remarkable image of beaten silver, gilt, and silver leaf, 8½″. She is the goddess who saves from trans-migratory existence; she is here represented with seven eyes. Besides the usual ones, she has an eye in her forehead, an eye in the palm of each hand, and an eye on the sole of each foot.

LOKAPALA, Gilded bronze, 6½–8″. These four deities are the Guardians of the Four Quarters of the Universe; they guard the gates to Mt. Sumeru, the center of the universe. Note the careful modeling, the symbols and expressions differing in each one. The halos at the back of each are cast separately and inserted by means of pins. The symbols also are cast separately and inserted. The details as to costume and ornamentation are finely worked out.

PADMASAMBHAVA, THE LOTUS BORN. Gilded bronze, 5¾″. Represents an Indian teacher who came to Tibet in the eighth century. He came from Udyana, a section of India famous for the practice of sorcery and magic. By fusing Mahayana Buddhist doctrines with those of the native Tibetan Pön, he founded what is known as Lamaism. This orthodox sect is familiarly known as the Red Cap Sect.

ATISHA. Molded from agglomerated materials, juniper dust, and clay, 5¼″. He instituted many reforms in the Red Cap Sect, founded the Ka-dam-pa Sect which was the forerunner of Tsong-kha-pa and the Ge-lug-pa Sect. Note the exquisite beauty of the face and hands. It is one of the finest examples we have ever seen.

TSONG-KHA-PA, THE MAN FROM TSONG (THE ONION COUNTRY). Gilded copper, $6\frac{1}{2}''$. The fifteenth-century reformer of Lamaism. He instituted reforms and discipline and founded the Yellow Cap Sect, now the dominant sect of Tibet. This Yellow Cap Sect is known as "The Virtuous Ones." Tsong-kha-pa was born in Sifan, near the western frontiers of China. The famous monastery of Kumbum is built there. Here also is the miraculous tree supposed to have sprung up at his birth; the leaves are said to bear pictures of deities or sacred letters.

NAG DBANG BLOB BZANG RGYA MTSHO. The Fifth Dalai Lama, 1617–1682; gilded bronze, $7\frac{1}{4}''$. He was the author of many books. His biography, in six volumes, is considered of great importance, both as a secular record and from the religious standpoint. Religious services are held every day at his tomb. He was greatly revered by the people and is known as the "Great Fifth."

A BARDO DEITY. One of the twenty-four Wang-chug-ma. Gilded bronze, $8\frac{1}{2}''$. This goddess with the head of a sea monster (*makara*) is one of the group of animal-headed deities appearing in the Bardo state.[9]

GARUDA. Mythical bird with golden wings; gilded bronze, $4\frac{15}{16}''$. The enemy of the snakes. He treads on a snake and on the nine-headed demon Rahu.

SARVABUDDHADAKINI. A Dakini (sky-goer); gilded bronze, $4\frac{3}{4}''$. She belongs to the group of deities who are invoked to grant superhuman powers.

A BARDO DEITY. One of the twenty-four Wang-chug-ma; gilded bronze, $8\frac{1}{2}''$. These animal- or bird-headed deities appear in the visions of the deceased before judgment and rebirth.[10]

There are many images which at present we must put under the head-

[9] See p. 23 for details.
[10] See p. 69 for illustrations.

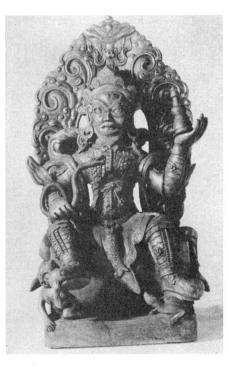

VIRUPAKSHA,
GUARDIAN OF THE WEST

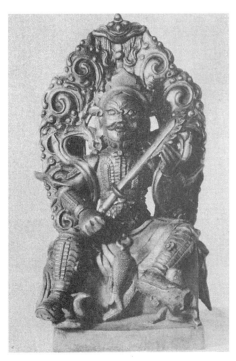

VIRUDHAKA,
GUARDIAN OF THE SOUTH

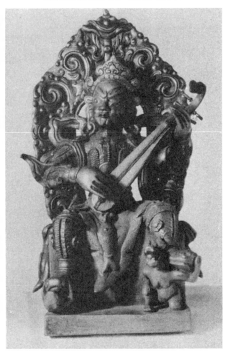

DHRITARASHTRA,
GUARDIAN OF THE EAST

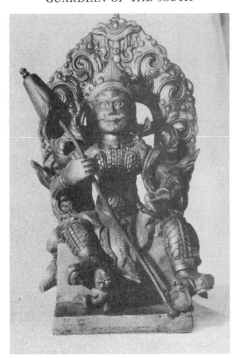

VAISRAVANA,
GUARDIAN OF THE NORTH

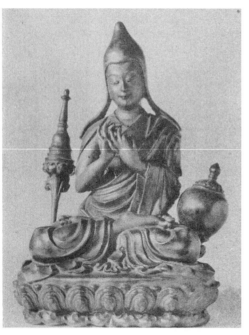

ATISHA,
TRANSLATOR AND TEACHER

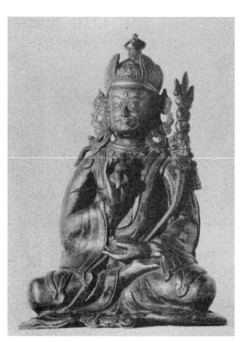

PADMASAMBHAVA, THE FOUNDER
OF THE RED CAP SECT

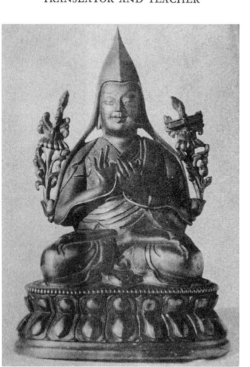

TSONG-KHA-PA, THE RE-
FORMER AND FOUNDER OF
THE YELLOW CAP SECT

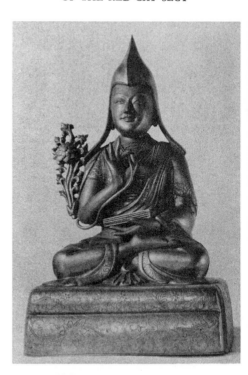

NAG DBANG BLOB BZANG
RGYA MTSHO, THE GREAT
FIFTH DALAI LAMA

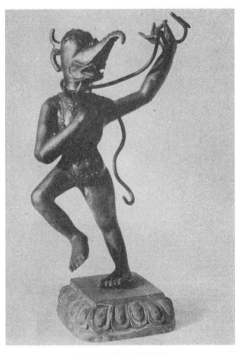

A BARDO DEITY

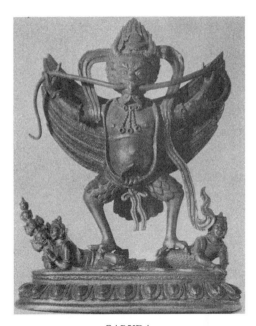

GARUDA

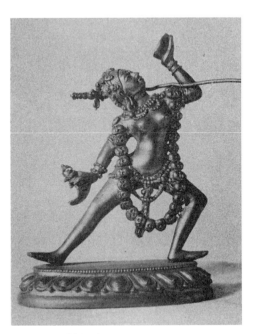

SARVABUDDHADAKINI

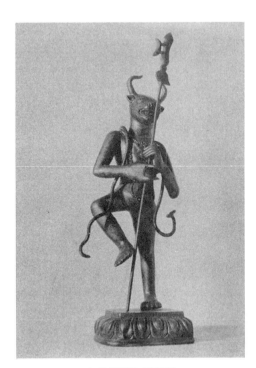

A BARDO DEITY

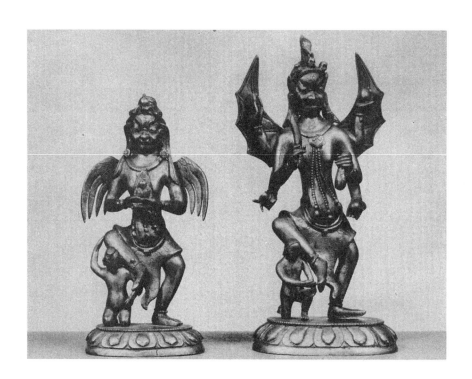

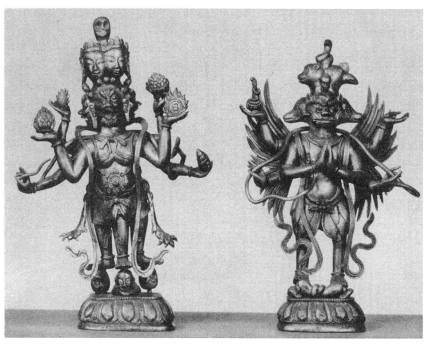

UNIDENTIFIED TIBETAN IMAGES

ing "Unidentified." Most of them are gilt bronze and very fine speci-
mens of casting. They do not conform to any Tibetan canonical de-
scriptions available at the present time; all have the Tibetan double
thunderbolt at the base, which identifies them as Tibetan. The wings on
many of the figures indicate that they may belong to the Pön, the
indigenous religion, or to the Red Cap Sect, which incorporated many
of the Pön deities into its pantheon.

The foregoing illustrations will serve to show the many different types
of figures, the methods of casting, and the reasons for certain uniform-
ities. The meticulous skill with which they are made in the many differ-
ent mediums, carrying out every detail set forth in the canon, is cause for
astonishment especially when one considers the difficulties of casting and
obtaining basic materials.

BOOKS AND WOOD BLOCKS

Books are objects of special reverence to the Tibetans. They are the repositories of all wisdom and are worshiped as divine. Books are inscribed by hand or printed from wood blocks. The manuscript illustrated on the opposite page is in the collection of the American Museum of Natural History. The paper is very heavy and fibrous. It is made from the bark of laurel trees, which are plentiful in Tibet. This paper is blue, a sacred color, and its characters are gold. It is Number 1 of the Book of Transcendental Wisdom.

The covers are made of two heavy plaques of wood, one above and one below the folios. They are carved with figures of deities and symbols and are gilded. The folios are tied together and wrapped in a silken cloth. The title page inside has a special brocade cover. Altogether, it is a very fine example of a Tibetan manuscript.

Books printed from wood blocks are usually smaller than manuscripts. Walnut is generally used for the blocks, which are incised on both sides. The carving is done by the lamas. The paper used is very thin, and eight sheets are pasted together to make one folio. The blocks are inked, and the folios are printed on both sides. Some of the folios also have images printed on them from the blocks and colored later by hand.

The Tanjur and Kanjur comprise 333 volumes. One can imagine the number of blocks needed. The three largest printing establishments in Tibet are at Narthang, Derge, and Choni. A few monasteries possess complete sets of both the Kanjur and the Tanjur. The Library of Congress, Washington, D.C., has a complete set, which was printed at the Choni Lamasery, and many volumes from the Derge and Narthang editions.

TIBETAN MANUSCRIPT; BOOK OF TRANSCENDENTAL WISDOM

TITLE PAGE OF THE MANUSCRIPT

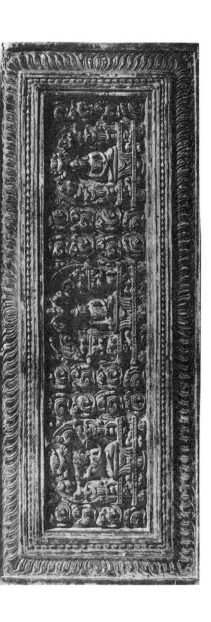

CARVED WOOD COVER OF A SACRED BOOK

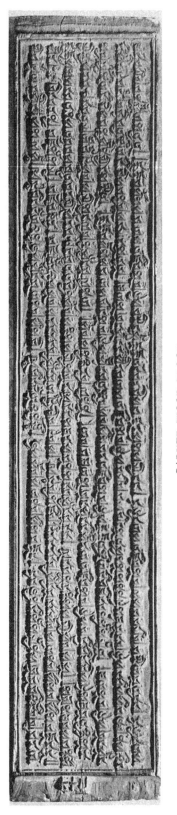

CARVED WOOD BLOCK

The illustration on page 73 is the title page of the manuscript shown on that page. It reads in transliteration:

rgya · gar · skad · du | arya · ashta · sa · ha · sra · ka · pradsnya · pa · ra · mi · ta || bod · skad · du | aphags · pa · shes · rab · kyi · pha · rold · tu · phyind · pa · brgyad · stong · pa || bam · po · dang · po ||

The literal translation:

In the Indian language | pure 8,000 (slokas) transcendental Wisdom | in the Tibetan language | pure Wisdom of the other shore 8,000 | section 1.

VOTIVE TABLETS

THERE ARE many different kinds of votive offerings to the Buddha and the deities. Offerings of the poor are often flowers, food, or votive tablets. The Buddha approved this. He said to Ananda, his favorite disciple, "Let it not be despised, as if it were not merit to bestow a little."[1]

The votive tablets are used on the altars of temples or family altars in the homes. They are sometimes made by the lamas and sold to the worshipers or pilgrims. Or they may be made by order of wealthy donors and presented to a particular temple. The cruder ones are made of clay, with the figure of a deity or group of deities impressed on the face. Sometimes an invocation is impressed on the back. More elaborate tablets are polychromed and gilded. A few are made of bronze, copper, or silver.

The clay votive tablets are made in molds (see illustrations on opposite page), then finished and colored by hand. The metal tablets are also made in molds and finished with hand tools.

The illustration of Beg-tse, God of War (opposite page), is one of a group of several hundred tablets made in the Chien Lung Dynasty. These are very beautifully molded and finished. On the back is an invocation and the name of the deity to whom offered, in Tibetan, Chinese, Mongolian, and Manchu characters.

[1] From "Lhai Metog" (Flower of the Gods); a story from the "Dsang-blun" (The Wise and the Foolish), a collection of stories told by the Buddha to his followers.

BRONZE MOLD
(INSIDE OF FRONT
SECTION)

BRONZE MOLD
(INSIDE OF BACK
SECTION)

BRONZE MOLD
(CLOSED)

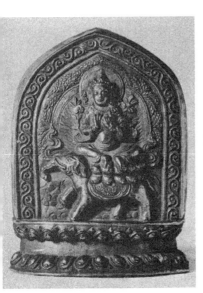

COPPER TABLET,
SHOWING
SAMANTABHADRA,
GOD OF HAPPINESS

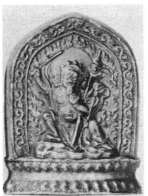

CLAY TABLET,
FROM MOLD,
SHOWING BEG-TSE,
GOD OF WAR

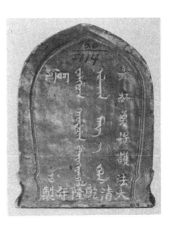

DATE ON BACK OF
CLAY TABLET (CHIEN
LUNG DYNASTY,
EIGHTEENTH CENTURY)
AND THE NAME OF THE
DEITY BEG-TSE

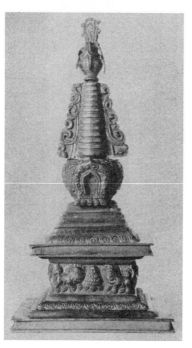

BRONZE RELIQUARY

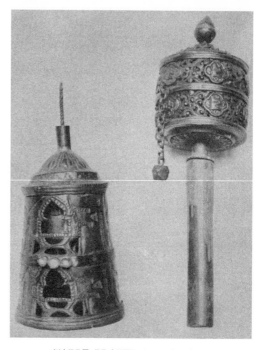

TABLE PRAYER WHEEL AND
HAND PRAYER WHEEL

ROSARY WITH SILVER COUNTERS
AND SILVER BELL AND
THUNDERBOLT

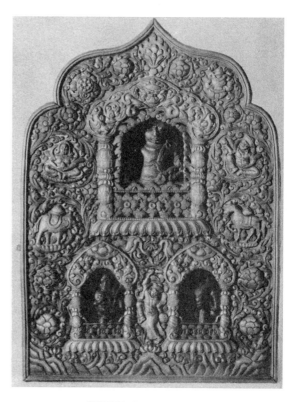

SILVER AMULET CASE
CONTAINING IMAGES
OF DEITIES

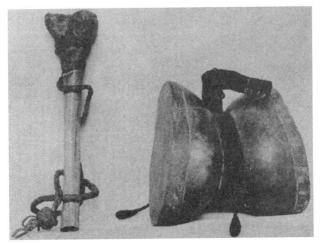

THIGH-BONE TRUMPET AND SKULL-DRUM

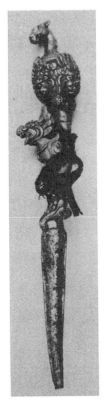

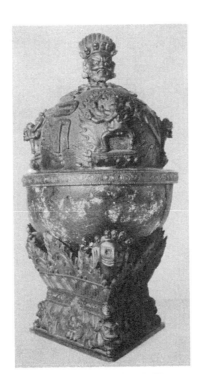

SKULL CUP ON STAND

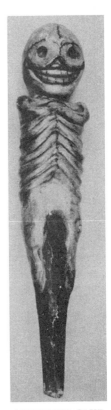

SKELETON CLUB

MAGIC DAGGER

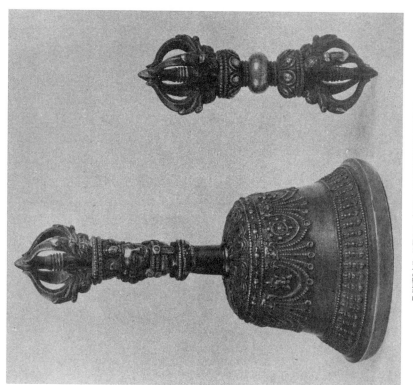

CONCH-SHELL TRUMPET

RITUAL BELL AND THUNDER-BOLT

RITUAL OBJECTS

FEW RELIGIONS have such a variety of ritual objects connected with their worship as does Lamaism.

The objects used comprise temple banners, images, books, tablets, musical instruments, amulets, charms, objects for the altar (such as holy water vases), cups for offerings of butter, water, incense and perfume, the Eight Symbols of Buddhism; the Seven Jewels of a Universal Monarch, and objects such as bells, thunderbolts, magic daggers, and many others used in the services by the lama celebrants.

Most of these ritual objects are made in the monasteries by the monks. The techniques and materials used in fashioning these objects are prescribed, as for all previously described religious art. The Buddhist canon contains the rules for making these images, whether painted or sculptured, and the exact measurements. It gives descriptions of the garments and ornaments, the hand poses *(mudras)*, the sitting or standing positions *(asanas)*, the mounts or thrones *(vahanas)*, the colors, and the symbols held. It is essential that these rules be rigidly observed, as color, symbol, and posture each have their special significance. It is considered a sin on the part of the artist not to adhere to the strict canonical rules.

In the temple services the following objects are used on the altar: The Eight Buddhist Symbols (the wheel, the lotus, the conch, the covered vase, the umbrella, the two fishes, the canopy, and the endless knot); cups for water, rice, flowers, and incense. Also, there will be butter lamps, the mandala, a large flat tray on which the lama offers daily to the gods the "Offering of the Universe," ewers containing holy water, with peacock feathers for sprinkling, skull cups with wine, reliquaries, and sacred cakes used as offerings.

In the services musical instruments are used: horns, trumpets, drums, flageolets, and cymbals. The lamas use "thunderbolts" and bells of bronze and rosaries of many different types, the colors and materials depending on the deity worshiped.

An important ritual object is the prayer wheel. This is a cylindrical metal case with a roll of prayers, printed on paper, inserted in it, and the cylinder mounted on a rod. The rod is twirled by hand from right to left. The type of prayer or invocation is most often the "Om mani padme hum" ("Hail to the jewel in the lotus"), which is the prayer calling upon the name of Avalokiteshvara (Lord of Mercy) for salvation. The dagger with triangular blade, called a *phur-bu*, is much used by the lamas for exorcising evil spirits.

Ornaments consisting of crowns, aprons, anklets, bracelets, and girdles of human bones, carved with the figures of deities and symbols, are worn in certain ceremonies.

The materials used for ritual objects include silver, copper, bronze, pewter, human bones, skulls, ivory, wood, coral, turquoise, pearls, and many kinds of beads made of minerals or seeds for the different types of rosaries. The silver repousse is very fine, as is shown in the illustrated amulet case. The bells and cymbals of bronze are beautifully cast and have very fine tones.

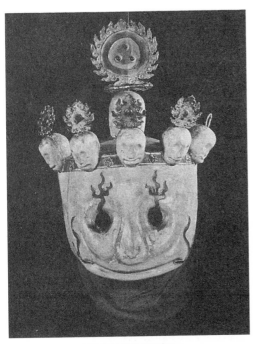

SKELETON MASK

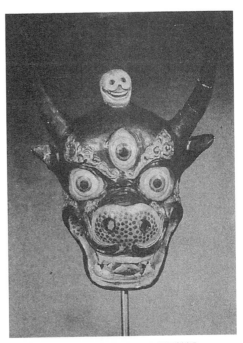

YAMA, THE GOD OF DEATH

HUMAN-BONE APRON

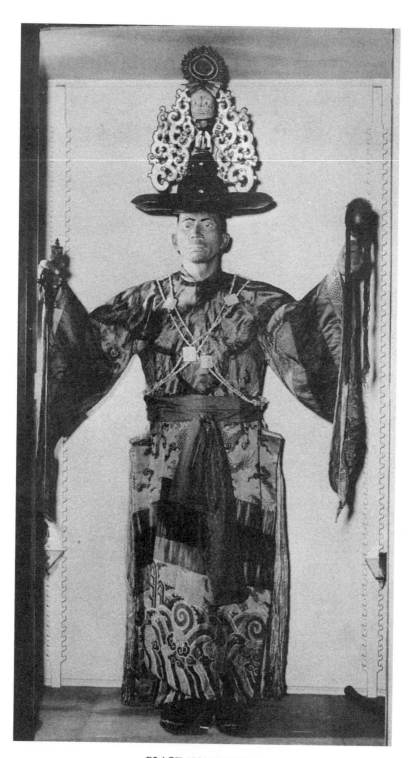

BLACK HAT DANCER

ROBES AND MASKS

EMBROIDERED AND BROCADED robes of gorgeous colors are used by the lama dancers in the mystery plays on festival days. These plays, sometimes called "devil dances," are usually acted out by the lamas. They depict some religious idea or event in the life of Buddha or the saints. Masks are constructed to fit over the head and rest on the shoulders of the dancers. They are molded of papier-mache thinly coated with plaster. Upon this the face is drawn and the color applied. Some masks are very elaborate and grotesque. In one play, called the "Black Hat Dance," high ornate headdresses are worn instead of masks. The brocaded robes are Chinese in origin, but the masks, headdresses, and dances are Tibetan. The dances are generally regarded as pre-Buddhist, or Pön. They are pantomimes, accompanied by occasional outcries and exclamations.

In the Dance of the Red Tiger Devil, danced at the end of the Old Year, the Pönist priest-magicians sought by cannabalism and human sacrifices to propitiate the deities and to exorcise the demons of bad luck. After the advent of Buddhism, the lamas modified these plays to suit their own purposes. The themes are religious or historical, and their purpose is to instruct the people in the doctrines of the faith and to demonstrate the power of The Religion.

During the festival there is generally a short introductory dance, or procession, then a comedy and finally the main dance of the day.

METAL WORK,
MUSICAL INSTRUMENTS,
AND JEWELRY

IN THE EARLY DAYS the best metal work came from Nepal. These objects were the models for the Tibetan craftsmen. At the present time the finest metal specimens come from the province of Derge. Such articles were at first used for religious purposes; for instance, the ritual objects used in the temple services, the ornate silver butter lamps used on the altars, the various types of bowls for scented water and flowers used for offerings to the deities. The objects in household use today are the copper, silver, and pewter jugs, teapots, and stands for teabowls, often decorated with intricate repousse work in Buddhist or symbolic designs.

The musical instruments are used mostly in the temple services. Various kinds of gongs and bells are sounded at certain pauses in the services. The metal used has a high silver content and produces beautiful tones. The long trumpets used to herald the dawn or for some special service have deep sonorous tones that can be heard for miles in the clear mountain air. They are made of copper and may be extended to a length of fifteen or twenty feet. Often they have symbolic designs engraved along their full length and elaborate silver ornamentation. Among the other musical instruments are flutes, oboes, flageolets, conch-shell trumpets, and cymbals.

TIBETAN POT FOR BUTTERED TEA. This pot of hammered copper with silver repousse is urn-shape upon a flanged decorated pedestal. The lid is decorated with lotus leaves, and a lotus bud forms the knob. The neck

TEA BOWL WITH STAND AND COVER (SILVER)

COPPER AND SILVER POT FOR BUTTERED TEA

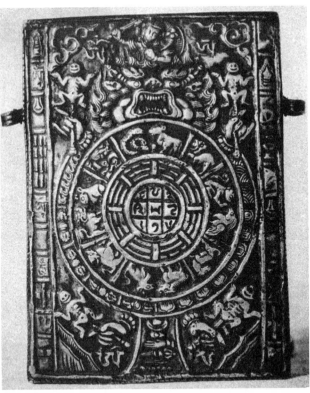

SILVER AMULET CASE WITH
HOROSCOPE DESIGN

SILVER AMULET CASE CONTAINING DEITY

AMULET BOX

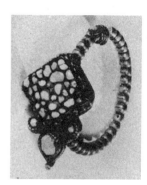

EARRINGS

is embossed with the Eight Glorious Symbols. The conch-shell trumpet at the base of the spout symbolizes victory.

This is a fine example of a Tibetan teapot, of the kind used by the monks. Its severe lines are enhanced by the highlights of the silver repousse, and the combination of two contrasting metals lend it a fine decorative quality. It comes from the monastery of Tashi-Lunpo, Shigatse, Tibet.

JEWELRY. Tibetans are very fond of jewelry, and it is worn by both men and women. Elaborate headdresses are worn by the women. These are made on a tall framework, and the hair is dressed to fall over it. The outline of the framework is studded with coral and turquoise, and elaborate earrings are fastened to the framework on each side.

One of the most popular forms of jewelry is the amulet box, or *gahu*, which is used by all the women. They are usually made of silver fili-gree studded with turquoise and coral. The necklace is made of beads of coral, turquoise, jade, or faience. The men often carry *gahus* on their saddlebags. These boxes contain prayers or small images of deities printed on paper, and they are used to bring good fortune and avert evil influences. They vary in workmanship and value according to the wealth of the wearer.

The men usually wear an earring in the left ear. On a long sash wrapped around them they fasten their pouches (for snuff), pen cases, ink pot, and sometimes a case containing eating utensils. The value and artistic merit of these utensils depend, of course, on the wealth of the wearer.

Valuable jewels worn by wealthy women are of gold, set with rubies, emeralds, and pearls. These are imported from India. The workmanship of the metal is often very fine, but the stones are crudely cut and not polished or faceted.

BUTTER SCULPTURE AND SAND MANDALAS

IN TIBET butter sculpture is considered a great art. The images of butter are used only for the particular festival celebrated on the fifteenth day of the first moon (month). As Tibetans follow the lunar calendar, the New Year usually occurs in February.

The images of deities and symbols are made by the lama artists of butter of many colors. The work is very difficult, since the lamas must keep the butter cold in order to be able to form and mold it.

The butter is mixed with various colored powders before the work of molding is begun. The completed images are attached to wooden panels or frames by means of ropes. As the festival lasts only twenty-four hours, the lamas usually arrange the butter images in the late afternoon. Thousands of butter lamps are kept burning all night for the people who come to worship the images.

The lamas also make *mandalas* of colored sand (see illustration on opposite page). These *mandalas* are exact representations of the "dwelling-place of the deity," which has been described on p. 24. Each one is made for some particular high lama, and worship is offered by him on a special day with a special ceremony. The one illustrated is a Kalachakra (Wheel of Time) *mandala*. It was made for the Panchen Lama for the ceremony celebrated October 21–23, 1932.

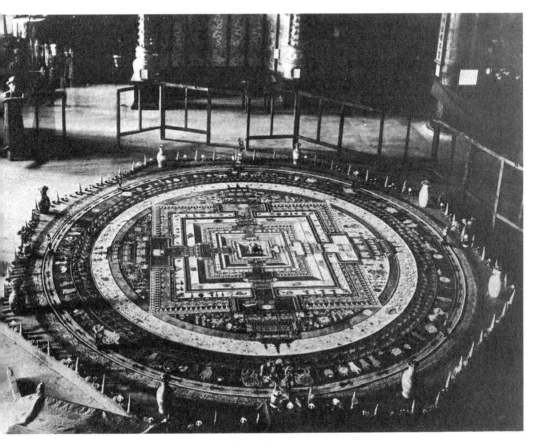

SAND MANDALA

CALLIGRAPHY

CALLIGRAPHY in Tibet, as in all Asiatic countries, is considered a fine art. Writing was not introduced into Tibet until the seventh century A.D. At that time King Srong Tsan Gampo sent a Tibetan, Thon-mi Sambhota, to India to study and bring back the Buddhist scriptures. Sambhota remained in Magadha for several years, becoming thoroughly versed in Buddhist philosophy, and he became known as a great scholar. Before his return to his native land this scholar invented an alphabet based on an old Devanagari (Sanskrit) alphabet, but adapted to the intricacies of Tibetan phonetics. He translated several Sanskrit texts by means of these new Tibetan characters. His grammar, composed in verse, is much venerated by Tibetan students.

Tibetan writing developed into several types. The types most commonly used are the *uchan* (headed letters) and the *umed*, (headless letters). The *uchan* is generally used for manuscripts and for printing books from wood blocks. There are several forms of *umed*, the principle forms of which are the hBam-yig, dPe-yig, and Khyug-yig, and their variations. There is also the cursive, or running hand, comparable to our script. In addition to these, there are several types of "sacred and ornamental writing" employed for religious or special manuscripts. Other varieties are the Brutscha and the Lantsha. A wooden quill-shape stylus is used for writing. The xylographs are blocks carved intaglio on both sides. Since the canonical books are considered sacred and revered as ritual objects, the most careful attention is given to clarity and beauty of style.

A fine example of the *hBam-yig* characters is the letter (reproduced opposite page. from His Holiness, the Dalai Lama, to the author. This letter is on hand-made paper (parchment color). Tibetan letters differ

EXAMPLE OF FINE CALLIGRAPHY

in size according to their purpose, whether they are official, diplomatic, or personal. This letter measures about $26'' + 26''$. It is written with black ink, and the official seal affixed is red.

CONCLUSION

THIS SHORT SURVEY of Tibetan Art leaves the impression that art in Tibet is truly a religious art. The infinite variety of forms and expressions executed in so many different media is astonishing. There are hundreds of individual deities or manifestations, each with his special characteristics. The moods portrayed, whether in painting or in sculpture, run the gamut of expression from the serene calm of a contemplative Buddha to the ferocity of a Dharmapala, a fierce Defender of the Faith.

Difficulties in casting and in the procuring of the necessary materials were enormous. Many of the basic materials were imported from China and India; the minerals and vegetables used in making the dyes came from remote parts of the country. Transporting them over the high mountain passes and snow-covered valleys at an altitude of more than ten thousand feet on muleback or yakback required much time and fortitude.

Among the thousand or more *thang-kas* and the innumerable images which the author has examined there is surprisingly little repetition, in spite of the rigid canonical restrictions. Evidently the artists found sufficient latitude to express themselves, because many of the paintings and images were made with consummate craftsmanship and a fine feeling for line, color, and perspective. Tibetan art is an anonymous art. Yet there were great painters and sculptors among the lamas, whose outstanding achievements deserve our respect and recognition.

Bkra-shis

BIBLIOGRAPHY

Arnold, Sir Edwin, The Light of Asia. London, 1884.
Avalon, Arthur, Shrichakrasambhara Tantra. London, 1919.
Bell, Sir Charles, The Portrait of the Dalai Lama. London, 1946.
——, The Religion of Tibet. Oxford, 1928.
Bhattacharyya, Benoytosh, Indian Buddhist Iconography. Calcutta, 1924.
——, Sadhanamala; a Buddhist Tantric Text of Rituals. Baroda, 1928.
Binyon, Laurence, Painting in the Far East. London, 1923.
Cammann, Schuyler, "Suggested Origin of the Tibetan Mandala Paintings,"
 The Art Quarterly, Spring, 1950.
Coomaraswamy, A. K., The Dance of Siva. New York, 1924.
d'Alviella, Count G., The Migration of Symbols. London, 1884.
Das, Sarat Chandra, A Tibetan-English Dictionary. Calcutta, 1882.
Davids, T. W. Rhys, Buddhist Birth Stories. London, 1880.
Evans-Wentz, W. J., Tibet's Great Yogi Milarepa. Oxford, 1928.
Fingesten, P., "Towards a New Definition of Religious Art," College Art
 Journal, X, No. 2 (1951), 131–146.
Fischer, O., Die Kunst Indiens, Chinas und Japans. Berlin, 1928.
Getty, Alice, The Gods of Northern Buddhism. Oxford, 1914.
Gordon, Antoinette K., The Iconography of Tibetan Lamaism. New York,
 1939.
Grünwedel, Albert, Mythologie des Buddhismus in Tibet und der Mongolei.
 Leipzig, 1900.
Hackin, J., and others, Asiatic Mythology. New York, n.d.
Hastings, James, ed., Encyclopedia of Religion and Ethics. Edinburgh and
 New York, 1908–1926.
Jaeschke, H. A., A Tibetan-English Dictionary. London, 1881.
Kufusaku, Zozo Ryodo-Kyo; Sutra of Measurements in Iconography. Pekin,
 1742.
Laufer, Berthold, Dokumente der indischen Kunst; das Citralaksana. Leipzig,
 1913.
Lessing, Ferdinand, D., Yung-Ho-Kung. Stockholm, 1942.
Li, An-che, "Tibetan Religion," in Forgotten Religions (New York, 1950),
 pp. 253–269.
McGovern, W. M., A Manual of Buddhist Philosophy. London, 1923.
Monier-Williams, Sir. M., A Sanskrit-English Dictionary. Oxford, 1872.

Olson, Eleanor, "Tibetan Applique Work," *The Bulletin of the Needle and Bobbin Club*, Vol. XXXIV, Nos. 1 and 2 (1950).

——, "A Tibetan Emblem of Sovereignty," *The Oriental Art Magazine* (London), Vol. III, No. 3 (1951).

Pallis, Marco, Peaks and Lamas. New York, 1940.

Pander, Eugen, Das Pantheon des Tschangtscha Hutuktu. Berlin, 1890.

Roerich, G., Tibetan Paintings. Paris, 1925.

Sankrityayana, Rahula, "Buddhist Painting in Tibet," *Asia Magazine*, XXXVII, No. 10 (October, 1937), 711–715.

"Technic in Tibetan Painting," *Asia Magazine*, XXXVII, No. 11 (November, 1937), 776–780.

Tucci, G., Tibetan Painted Scrolls. Rome, 1950.

Vidyabhusana, S. C., On Certain Tibetan Scrolls and Images. Calcutta, 1905. Memoirs of the Asiatic Society of Bengal, Vol. I, No. 1.

Waddell, L. A., The Buddhism of Tibet or Lamaism. London, 1895.

Warren, H. C., Buddhism in Translations. Cambridge, Mass., 1947. Harvard Oriental Series.

Weber, V.-F., Ko-ji Ho-ten. Paris, 1923.

INDEX

A CATALOG OF SELECTED
DOVER BOOKS
IN ALL FIELDS OF INTEREST

A CATALOG OF SELECTED DOVER
BOOKS IN ALL FIELDS OF INTEREST

CONCERNING THE SPIRITUAL IN ART, Wassily Kandinsky. Pioneering work by father of abstract art. Thoughts on color theory, nature of art. Analysis of earlier masters. 12 illustrations. 80pp. of text. 5⅜ x 8½. 23411-8

ANIMALS: 1,419 Copyright-Free Illustrations of Mammals, Birds, Fish, Insects, etc., Jim Harter (ed.). Clear wood engravings present, in extremely lifelike poses, over 1,000 species of animals. One of the most extensive pictorial sourcebooks of its kind. Captions. Index. 284pp. 9 x 12. 23766-4

CELTIC ART: The Methods of Construction, George Bain. Simple geometric techniques for making Celtic interlacements, spirals, Kells-type initials, animals, humans, etc. Over 500 illustrations. 160pp. 9 x 12. (Available in U.S. only.) 22923-8

AN ATLAS OF ANATOMY FOR ARTISTS, Fritz Schider. Most thorough reference work on art anatomy in the world. Hundreds of illustrations, including selections from works by Vesalius, Leonardo, Goya, Ingres, Michelangelo, others. 593 illustrations. 192pp. 7⅛ x 10¼. 20241-0

CELTIC HAND STROKE-BY-STROKE (Irish Half-Uncial from "The Book of Kells"): An Arthur Baker Calligraphy Manual, Arthur Baker. Complete guide to creating each letter of the alphabet in distinctive Celtic manner. Covers hand position, strokes, pens, inks, paper, more. Illustrated. 48pp. 8¼ x 11. 24336-2

EASY ORIGAMI, John Montroll. Charming collection of 32 projects (hat, cup, pelican, piano, swan, many more) specially designed for the novice origami hobbyist. Clearly illustrated easy-to-follow instructions insure that even beginning papercrafters will achieve successful results. 48pp. 8¼ x 11. 27298-2

THE COMPLETE BOOK OF BIRDHOUSE CONSTRUCTION FOR WOOD-WORKERS, Scott D. Campbell. Detailed instructions, illustrations, tables. Also data on bird habitat and instinct patterns. Bibliography. 3 tables. 63 illustrations in 15 figures. 48pp. 5¼ x 8½. 24407-5

BLOOMINGDALE'S ILLUSTRATED 1886 CATALOG: Fashions, Dry Goods and Housewares, Bloomingdale Brothers. Famed merchants' extremely rare catalog depicting about 1,700 products: clothing, housewares, firearms, dry goods, jewelry, more. Invaluable for dating, identifying vintage items. Also, copyright-free graphics for artists, designers. Co-published with Henry Ford Museum & Greenfield Village. 160pp. 8¼ x 11. 25780-0

HISTORIC COSTUME IN PICTURES, Braun & Schneider. Over 1,450 costumed figures in clearly detailed engravings–from dawn of civilization to end of 19th century. Captions. Many folk costumes. 256pp. 8⅜ x 11¾. 23150-X

STICKLEY CRAFTSMAN FURNITURE CATALOGS, Gustav Stickley and L. & J. G. Stickley. Beautiful, functional furniture in two authentic catalogs from 1910. 594 illustrations, including 277 photos, show settles, rockers, armchairs, reclining chairs, bookcases, desks, tables. 183pp. 6½ x 9¼. 23838-5

AMERICAN LOCOMOTIVES IN HISTORIC PHOTOGRAPHS: 1858 to 1949, Ron Ziel (ed.). A rare collection of 126 meticulously detailed official photographs, called "builder portraits," of American locomotives that majestically chronicle the rise of steam locomotive power in America. Introduction. Detailed captions. xi+ 129pp. 9 x 12. 27393-8

AMERICA'S LIGHTHOUSES: An Illustrated History, Francis Ross Holland, Jr. Delightfully written, profusely illustrated fact-filled survey of over 200 American lighthouses since 1716. History, anecdotes, technological advances, more. 240pp. 8 x 10¾.
25576-X

TOWARDS A NEW ARCHITECTURE, Le Corbusier. Pioneering manifesto by founder of "International School." Technical and aesthetic theories, views of industry, economics, relation of form to function, "mass-production split" and much more. Profusely illustrated. 320pp. 6⅛ x 9¼. (Available in U.S. only.) 25023-7

HOW THE OTHER HALF LIVES, Jacob Riis. Famous journalistic record, exposing poverty and degradation of New York slums around 1900, by major social reformer. 100 striking and influential photographs. 233pp. 10 x 7⅞. 22012-5

FRUIT KEY AND TWIG KEY TO TREES AND SHRUBS, William M. Harlow. One of the handiest and most widely used identification aids. Fruit key covers 120 deciduous and evergreen species; twig key 160 deciduous species. Easily used. Over 300 photographs. 126pp. 5⅜ x 8½. 20511-8

COMMON BIRD SONGS, Dr. Donald J. Borror. Songs of 60 most common U.S. birds: robins, sparrows, cardinals, bluejays, finches, more–arranged in order of increasing complexity. Up to 9 variations of songs of each species.
Cassette and manual 99911-4

ORCHIDS AS HOUSE PLANTS, Rebecca Tyson Northen. Grow cattleyas and many other kinds of orchids–in a window, in a case, or under artificial light. 63 illustrations. 148pp. 5⅜ x 8½. 23261-1

MONSTER MAZES, Dave Phillips. Masterful mazes at four levels of difficulty. Avoid deadly perils and evil creatures to find magical treasures. Solutions for all 32 exciting illustrated puzzles. 48pp. 8¼ x 11. 26005-4

MOZART'S DON GIOVANNI (DOVER OPERA LIBRETTO SERIES), Wolfgang Amadeus Mozart. Introduced and translated by Ellen H. Bleiler. Standard Italian libretto, with complete English translation. Convenient and thoroughly portable–an ideal companion for reading along with a recording or the performance itself. Introduction. List of characters. Plot summary. 121pp. 5¼ x 8½. 24944-1

TECHNICAL MANUAL AND DICTIONARY OF CLASSICAL BALLET, Gail Grant. Defines, explains, comments on steps, movements, poses and concepts. 15-page pictorial section. Basic book for student, viewer. 127pp. 5⅜ x 8½. 21843-0

AUTOBIOGRAPHY: The Story of My Experiments with Truth, Mohandas K. Gandhi. Boyhood, legal studies, purification, the growth of the Satyagraha (nonviolent protest) movement. Critical, inspiring work of the man responsible for the freedom of India. 480pp. 5⅜ x 8½. (Available in U.S. only.) 24593-4

CELTIC MYTHS AND LEGENDS, T. W. Rolleston. Masterful retelling of Irish and Welsh stories and tales. Cuchulain, King Arthur, Deirdre, the Grail, many more. First paperback edition. 58 full-page illustrations. 512pp. 5⅜ x 8½. 26507-2

THE PRINCIPLES OF PSYCHOLOGY, William James. Famous long course complete, unabridged. Stream of thought, time perception, memory, experimental methods; great work decades ahead of its time. 94 figures. 1,391pp. 5⅜ x 8½. 2-vol. set.
Vol. I: 20381-6 Vol. II: 20382-4

THE WORLD AS WILL AND REPRESENTATION, Arthur Schopenhauer. Definitive English translation of Schopenhauer's life work, correcting more than 1,000 errors, omissions in earlier translations. Translated by E. F. J. Payne. Total of 1,269pp. 5⅜ x 8½. 2-vol. set. Vol. 1: 21761-2 Vol. 2: 21762-0

MAGIC AND MYSTERY IN TIBET, Madame Alexandra David-Neel. Experiences among lamas, magicians, sages, sorcerers, Bonpa wizards. A true psychic discovery. 32 illustrations. 321pp. 5⅜ x 8½. (Available in U.S. only.) 22682-4

THE EGYPTIAN BOOK OF THE DEAD, E. A. Wallis Budge. Complete reproduction of Ani's papyrus, finest ever found. Full hieroglyphic text, interlinear transliteration, word-for-word translation, smooth translation. 533pp. 6½ x 9¼. 21866-X

MATHEMATICS FOR THE NONMATHEMATICIAN, Morris Kline. Detailed, college-level treatment of mathematics in cultural and historical context, with numerous exercises. Recommended Reading Lists. Tables. Numerous figures. 641pp. 5⅜ x 8½.
24823-2

PROBABILISTIC METHODS IN THE THEORY OF STRUCTURES, Isaac Elishakoff. Well-written introduction covers the elements of the theory of probability from two or more random variables, the reliability of such multivariable structures, the theory of random function, Monte Carlo methods of treating problems incapable of exact solution, and more. Examples. 502pp. 5⅜ x 8½. 40691-1

THE RIME OF THE ANCIENT MARINER, Gustave Doré, S. T. Coleridge. Doré's finest work; 34 plates capture moods, subtleties of poem. Flawless full-size reproductions printed on facing pages with authoritative text of poem. "Beautiful. Simply beautiful."–*Publisher's Weekly.* 77pp. 9¼ x 12. 22305-1

NORTH AMERICAN INDIAN DESIGNS FOR ARTISTS AND CRAFTSPEOPLE, Eva Wilson. Over 360 authentic copyright-free designs adapted from Navajo blankets, Hopi pottery, Sioux buffalo hides, more. Geometrics, symbolic figures, plant and animal motifs, etc. 128pp. 8⅜ x 11. (Not for sale in the United Kingdom.) 25341-4

SCULPTURE: Principles and Practice, Louis Slobodkin. Step-by-step approach to clay, plaster, metals, stone; classical and modern. 253 drawings, photos. 255pp. 8⅛ x 11.
22960-2

THE INFLUENCE OF SEA POWER UPON HISTORY, 1660–1783, A. T. Mahan. Influential classic of naval history and tactics still used as text in war colleges. First paperback edition. 4 maps. 24 battle plans. 640pp. 5⅜ x 8½. 25509-3

THE STORY OF THE TITANIC AS TOLD BY ITS SURVIVORS, Jack Winocour (ed.). What it was really like. Panic, despair, shocking inefficiency, and a little heroism. More thrilling than any fictional account. 26 illustrations. 320pp. 5⅜ x 8½.
20610-6

FAIRY AND FOLK TALES OF THE IRISH PEASANTRY, William Butler Yeats (ed.). Treasury of 64 tales from the twilight world of Celtic myth and legend: "The Soul Cages," "The Kildare Pooka," "King O'Toole and his Goose," many more. Introduction and Notes by W. B. Yeats. 352pp. 5⅜ x 8½.
26941-8

BUDDHIST MAHAYANA TEXTS, E. B. Cowell and others (eds.). Superb, accurate translations of basic documents in Mahayana Buddhism, highly important in history of religions. The Buddha-karita of Asvaghosha, Larger Sukhavativyuha, more. 448pp. 5⅜ x 8½.
25552-2

ONE TWO THREE . . . INFINITY: Facts and Speculations of Science, George Gamow. Great physicist's fascinating, readable overview of contemporary science: number theory, relativity, fourth dimension, entropy, genes, atomic structure, much more. 128 illustrations. Index. 352pp. 5⅜ x 8½.
25664-2

EXPERIMENTATION AND MEASUREMENT, W. J. Youden. Introductory manual explains laws of measurement in simple terms and offers tips for achieving accuracy and minimizing errors. Mathematics of measurement, use of instruments, experimenting with machines. 1994 edition. Foreword. Preface. Introduction. Epilogue. Selected Readings. Glossary. Index. Tables and figures. 128pp. 5⅜ x 8½.
40451-X

DALÍ ON MODERN ART: The Cuckolds of Antiquated Modern Art, Salvador Dalí. Influential painter skewers modern art and its practitioners. Outrageous evaluations of Picasso, Cézanne, Turner, more. 15 renderings of paintings discussed. 44 calligraphic decorations by Dalí. 96pp. 5⅜ x 8½. (Available in U.S. only.)
29220-7

ANTIQUE PLAYING CARDS: A Pictorial History, Henry René D'Allemagne. Over 900 elaborate, decorative images from rare playing cards (14th–20th centuries): Bacchus, death, dancing dogs, hunting scenes, royal coats of arms, players cheating, much more. 96pp. 9¼ x 12¼.
29265-7

MAKING FURNITURE MASTERPIECES: 30 Projects with Measured Drawings, Franklin H. Gottshall. Step-by-step instructions, illustrations for constructing handsome, useful pieces, among them a Sheraton desk, Chippendale chair, Spanish desk, Queen Anne table and a William and Mary dressing mirror. 224pp. 8⅛ x 11¼.
29338-6

THE FOSSIL BOOK: A Record of Prehistoric Life, Patricia V. Rich et al. Profusely illustrated definitive guide covers everything from single-celled organisms and dinosaurs to birds and mammals and the interplay between climate and man. Over 1,500 illustrations. 760pp. 7½ x 10⅛.
29371-8